THE POSTCARD HISTORY SERIES

Chatham

MASSACHUSETTS

To Colleen

Happy Birthday

Chris

xx

8ᵗʰ July 2000

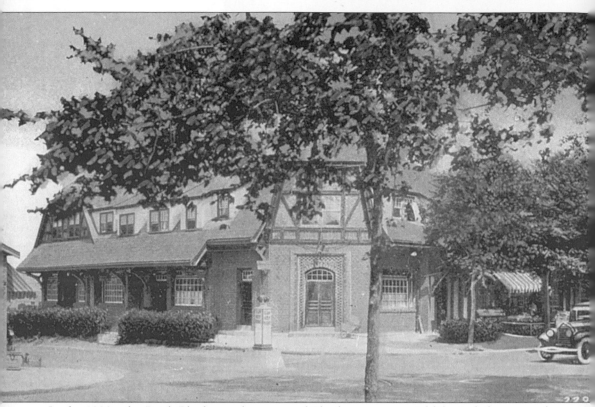

In the 1930s, the Brick Block was the center of Chatham commercial life. A daily stop at the post office, at Quiltys, or the Mayflower across the street to buy a newspaper was a part of many Chathamite's day. A small monument with a flashing light was placed in the late 1920s at the junction of Chatham Bars Avenue and Main Street to organize traffic. It was only present for a few years before it was removed and the roads widened.

The Postcard History Series

Chatham
Massachusetts

Robert E. Zaremba and Danielle R. Jeanloz

Published by Arcadia Publishing,
an imprint of Tempus Publishing, Inc.
2 Cumberland Street
Charleston, SC 29401

Printed in Great Britain.

Library of Congress Catalog Card Number: Applied for.

For all general information contact Arcadia Publishing at:
Telephone 843-853-2070
Fax 843-853-0044
E-Mail arcadia@charleston.net

For customer service and orders:
Toll-Free 1-888-313-BOOK

Visit us on the internet at http://www.arcadiaimages.com

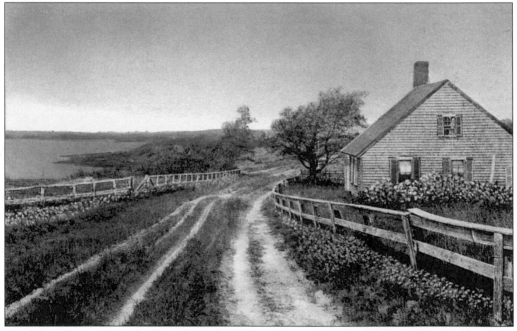

The "Cozy Cottage" was built in the early 1800s and is an example of a "half Cape," with a front door to one side flanked by a pair of windows. It is much smaller than a "full Cape," which often includes a parlor in the front with a kitchen/public room to the back, and bedrooms in a loft arrangement up a steep flight of stairs. Cozy Cottage was built on Old Queen Anne Road overlooking Oyster Pond. This view, photographed by Harold Sawyer, was a popular postcard for many years. The cottage still exists and, although modified, is still recognizable along the short section of Old Queen Anne Road between the rotary and Pond Street.

CONTENTS

INTRODUCTION

In 1905, at the time of the first postcards of Chatham, Massachusetts, the town was thriving. The nation as a whole was prosperous. The railroad had come to the village only nine years earlier and had brought about a rapid expansion of the tourist market. New businesses were developing. Descendants of early Chatham families were returning to town to build large homes and make contributions to the village.

But Chatham was barely out of the 19th century and still a very small town. Horses and carriages were the main means of distant transportation. Most people didn't travel far in their daily lives—mainly, they walked. The streets were unpaved, narrow sandy trails for the most part. The Civil War was only 40 years past and electricity was not universal.

At the turn of the century, Chatham was already rich in history, going back 240 years to the earliest Nickerson settlers. Many buildings that we now think of as old (built around 1800) were barely 100 years old. Parts of the Chatham we know today were just beginning to emerge. The Hotel Chatham was an abandoned hulk soon to be torn down, dominating the profile of Nickerson Neck in Chathamport; the Mattaquason Inn was the luxury hotel in town; and Chatham Bars Inn was nine years from being built. Chatham Light was still a pair of lighthouses and the rapid shoreline erosion of the 1870s was a clear memory.

For the first 30 years of the 20th century, the number of Chatham visitors increased dramatically each year. First, there were the wealthy who came by packet ship, and then by train, and stayed for much of the summer at the big hotels. Then, the emerging middle class came by train and soon by car, staying at smaller inns and guesthouses. Eventually, laborers from the mills in the industrial cities were able to get to town for short stays at small informal guesthouses. They all bought postcards.

From 1905 to the Second World War, a series of scenic postcards documented the character of the town and the changing emphasis of what appealed to visitors. Water in great diversity is everywhere in these cards. This water, both salty and fresh, with waves and dead calm, warm and cold, is the backdrop of most scenes. Some early cards included people in the scenes, but later cards seem to have become more general, allowing the observers to insert themselves into the tranquil setting.

Early cards produced by the Rotograph Company, Wentworth, and Dickerman were made in large quantities featuring the signature images of town: the Twin Lights, the view of Chatham Harbor, Stage Harbor, the Mill Pond, Main Street, and the Mattaquason Hotel. Later in the 1920s, Harold Sawyer, a well-known New England photographer, produced a series of beautiful hand-colored images of town focusing on coastal landscapes, old houses, and village scenes. Cards were produced locally by the Mayflower Shop and Quiltys. Beginning in the 1930s, E.D.West Company produced cards throughout the Cape, including many in Chatham. Beyond these high production cards, there were also innumerable "real photo" cards made generally in very small quantities of a far broader range of subjects, including private homes, small hotels, beach scenes, and Chatham oddities. These cards document the backdrop from which the current landscape has emerged.

There are easily over 500 different Chatham postcards made before 1940. These are, collectively, a valuable resource that illustrates the changing town landscape. Combined with reminiscences, personal photographs, newspaper articles, and scholarly reports, postcards offer a visual connection between past and present. This is, of course, true in many places, but it is

particularly true in Chatham, which has always been highly regarded for its scenic beauty. This book includes nearly 200 postcard images of Chatham from a range of subjects including the Old Village, Main Street, Chathamport, and North Chatham. Only West Chatham and South Chatham have not been included. The images mainly cover the period from 1905 to 1940, with a few select scenes from later periods.

To get to Chatham, it has always been necessary to go a little bit out of your way—to venture through the dangerous sandbars around the harbor entrances, to take the extra train out of Harwich, and today, to wander along secondary roads off Route 6. Chatham was the last Cape town to get train service and the first to lose it. In Massachusetts, the sun rises first in Chatham, but often the sun doesn't shine in town when it is sunny over the rest of the Cape. The fog lingers a little longer in Chatham. The character of the town, the people, the institutions, and the buildings follow these differences, making Chatham unlike other Cape towns. Chatham has a well-developed sense of itself, an identity apart from other areas. The connections to the past are all around us. Those who live in town and even those who visit for only a short while are easily caught up in the calm seaside setting rich in history. People in Chatham once again walk. Postcards, and local histories, in general, give context to our daily lives and enrich our sense of who we are and how we fit into these strong local traditions.

Acknowledgments

This history of Chatham is really the work of many people who have been a part of our experience of the town over the past 30 years. I arrived in Chatham in the 1960s and worked throughout the Old Village during summers. My first knowledge of Chatham came as stories of shipwrecks, mooncussers, old houses, and chowder recipes told to a teenager by older people who were eager to share their personal stories of town. I was curious and full of questions, but I wish I had asked more and I do wish I had written down a few of their stories. Thanks for my training in Chatham background goes to many who are no longer with us: Art Gould, Betty and Dave Ovans, Tom Pennypacker, Lucille Tuttle, Harold Tuttle, Lois Balladur, Elizabeth Fuller, George Lake, Mrs. Fallon, Mrs. Adams, and Dr. Perry. Their interest in Chatham and their interest in me are much appreciated.

When we started this project, we thought we had a great collection of postcards and an adequate knowledge of the town to write a respectable history. It didn't take long to learn that while our collection is good, it isn't even one of the best in town. There are some wonderful collections of Chatham memorabilia and far more talented Chatham historians. The more I have learned about the sources of information about Chatham, the more I am amazed and encouraged by the openness with which people shared their collections, information, and thoughts about the town. Most people showed interest in the project and, while very busy, were willing to help as they could. I kept thinking that I would be chased out by longtime residents thinking "Who is this guy, an occasional summer visitor for over 30 years? What does he know?" Well, they may think that, but they have not said it to me nor even suggested it in their tone. These old friends and new acquaintances have been fully engaged in this work.

Thanks go to Spencer Gray and the staff of the Chatham Historical Society, including Hilda Traina, who shared information from their postcard and photographic collections and from their personal knowledge of the town.

Thank you to Amy Lux, reference librarian at the Eldredge Public Library, for whom no detailed task seemed to be too difficult. Amy convinced me that the resource staff at libraries are the unsung heroes of all recent histories. Thanks also to Paul Hammersten and the staff of the Eldredge Public Library who suffered long strings of seemingly unconnected questions.

We appreciate the help of Nancy Ryder Petrus, Donna Lumpkin, Wayne Gould, and the Eldredge Public Library who allowed us to use some of their cards, photographs, and maps. We

are grateful to Donna Lumpkin, Noel Beyle, Richard and Carolyn Thompson, and Richard Hutchinson for sharing their interest in Chatham postcards. Henry Barbour, Richard Ryder and Wayne Gould were helpful in providing specific details on Chatham.

Nancy Ryder Petrus, Jane Tuttle Powers, Beatrice Zaremba, and Joe Nickerson contributed their time by reading and making useful and sometimes humorous comments on the first draft.

And a special thanks to Joe Nickerson, who shared so willingly and unsparingly with a stranger his vast knowledge of Chatham history, both large-scale and small. We hope he likes the result.

This is not a scholarly work. We are aware that there may be errors in content and for that we take full responsibility and seek correction, whenever appropriate.

I have been a conservation biologist for 25 years, working first for the Massachusetts Audubon Society and more recently for The Nature Conservancy. To raise money for these nonprofit groups, we rely on private donations. Some of this money is given to support the pursuit of protecting habitat for species against human disturbance. But more often, people give because they love a place that they have come to know in personal terms, and love it as a part of themselves. That is, obviously, no less true for a place like Chatham. Chatham is truly a beautiful place, one of the best. But, it is also a place that has, for its entire existence, had a self-confidence and sense of where it has come from that builds a strong and vibrant character that seems to touch all those who interact with it.

Robert E. Zaremba
August 1999

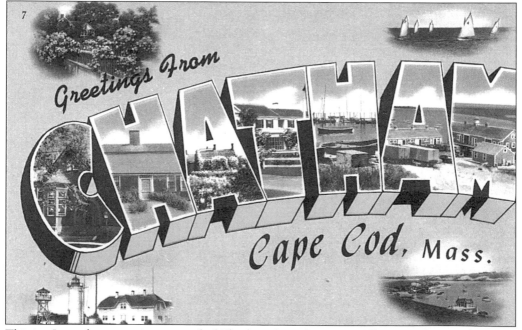

This is a Large-letter tourist postcard of Chatham from the 1940s. All images that are shown on this card appear within this book.

One
CHATHAM LIGHT

This story of Chatham begins with the lighthouse—the Chatham Light. No other Chatham image is as recognizable and captures the character of this village by the sea. The pulse of the twin beams against houses and trees reminds visitors throughout the Old Village and beyond that Chatham is strategically positioned along the Cape coast. It has welcomed ships from Europe and played a key role in protecting boats sailing along the East Coast from Boston to New York, around the dangerous waters of Pollock Rip.

The lighthouse was also the town connection to national life, a main unit of the elaborate Lifesaving Service and later the Coast Guard. The first lighthouse was built in 1808 and replaced by a pair of lighthouses in 1840, which were replaced again in 1877. Within the shadow of the lights, the maritime commercial life of 19th and early 20th century Chatham was played out. Early tourism thrived within a short walk; beautiful summer homes were built under its watch; and nearby thousands of boaters and beach lovers, both local and from afar, developed a love of coastal New England.

The role of the lighthouse has changed over time. It is no longer highly functional as a seaside safeguard in an age of computerized satellite navigation. The image of the twin beams throughout the year, during storms, on fair summer evenings, and in the gray doldrums of the spring and fall remains an enduring symbol of Chatham.

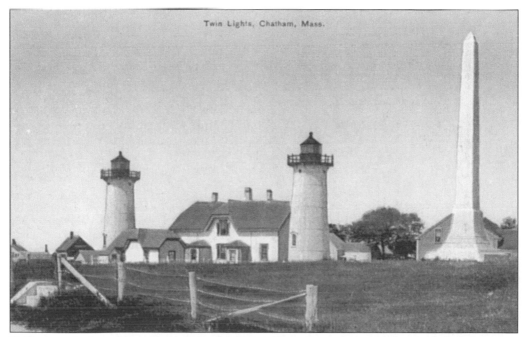

Twin Lights, Chatham, Mass.

Sailing north from Nantucket along the Outer Cape, boats first saw the single lighthouse at Monomoy, followed soon after by the pair of lighthouses at Chatham, and then the three lighthouses at Nauset in Eastham. The Chatham Twin Lights in the heart of the Old Village was the most accessible of these lighthouses to early tourists. It was the subject of numerous postcards, such as this German-made card by Howard from about 1910.

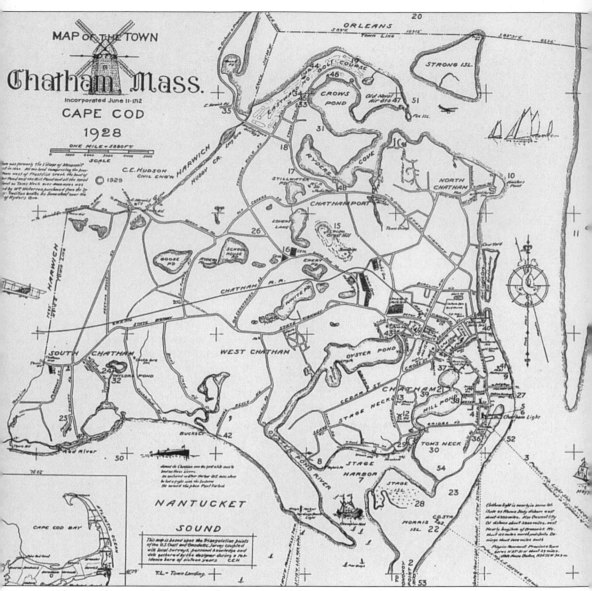

This 1928 map of Chatham shows most of the significant locations in town and Chatham's critical position along the east coast of Cape Cod. Sand eroded from the cliffs of Truro, Wellfleet, and Eastham is carried by waves northward to form the Provincetown Spit and southward to form the barrier beaches of Nauset, North and South Beaches in Chatham, and

POINTS OF HISTORICAL INTEREST IN CHATHAM

1. Nauset Beach - "Wonder Strands" of the Norsemen.(986 A.D.)

2. Monomoy Point - "Cape Mallebarre" of the early explorers.

3. Pollack Rip Light-Ship - marking "Tucker's Terror" the approximate point at which the Pilgrims turned back to Plymouth (November, 1620).

4. Chatham Light-House, one of the earliest aids to Mariners.

5. Mack Monument - memorial to William Mack, his captain and crew of the barge "Wadena", and the seven men of Monomoy Life Saving Station who were drowned while attempting to rescue them. (1902). As a result of this disaster, Point Rip Life Saving Station was established at the tip of Monomoy Point.

6. Burial ground of the unknown dead whose bodies have been washed ashore at Chatham. Between Nauset and Nantucket have occurred one-half of the total known wrecks on the whole Atlantic and Gulf of Mexico Coasts of the United States. In the twenty years, 1887 to 1907, enough vessels were lost between Provincetown and Monomoy Point to form a solid bulwark along the entire coast between these points.

7. Stage Harbor - called Stage Harbor from the presence here of fishing stages for curing fish - called, Port "Fortune" by Samuel de Champlain (1606).

8. Scene of Champlain's "encounter with the Savages" - Here was shed the first blood in all New England in conflict between Europeans and Indians.

9. Watch Hill, fortified in 1812 by Colonel David Godfrey who lived in house just south of Old Mill.(12).

10. "Scatteree" - anchorage of Gosnold (1602) who sailed in through entrance then at about present location of Old Harbor Coast Guard Station. (11).

11. Old Harbor Coast Guard Station. Just north of this was wrecked the "Sparrow Hawk" (1626) (now restored in Plymouth Memorial Hall at Plymouth, Massachusetts.) At this point in December 1896 was lost the three-masted Schooner "Calvin B. Orcutt" with all hands, the only wreck on Chatham shores within the memory of man where the men of the shore knowing the wreck was there, were unable to recover the bodies either dead or alive. As a result, Old Harbor Life Saving Station was built in 1897.

12. Old Grist Mill - Built by Colonel David Godfrey prior to 1774.

13. Old Atwood Homestead - Oldest house in Chatham, (built about 1756) now owned and occupied by Chatham Historical Society.

14. Chatham Bars Inn - Formerly part of the farm of Squire Richard Sears (1800) who lived in the style of the old Country Squire.

15. Great Hill - Famous "Western Ocean" landfall. To hold the sand from blowing over and burying the village, beach grass and then pines were planted in 1821. Earliest known experiment in reforestation in America.

16. Old Cemeteries - Center of the original Settlement - The road leading south from here was the division line between the "Inlands" of private ownership on the East, and the Outlands" of common ownership on the West. (Seventeenth Century)

17. Old Burying Ground - last burial place of the Indians, and first burial place of the Whites.

18. Farm of William Nickerson, the first settler in Chatham. (1656).

19. Old Ship Yard - Here were built fishing and trading vessels as late as 1850.

20. Pleasant Bay - known as "Sutcliffe's Inlet" prior to 1619. (Said to be rendezvous of early New England pirates.)

21. Site of early tide-mill for grinding corn.

22. Chatham Coast Guard Station - In 1880 it was the eleventh on the Atlantic Coast. It has been moved back three times to save it from the sea.

23. Former entrance to Stage Harbor, probable reason for Indian name of "Monomoyick" for this place.

24. Location of old tide-mill for grinding corn.

25. In 1815 there stood here the last remnant (about twenty-five acres) of the primeval forests which once ran to the water's edge.

26. The Training Field of the Colonial Militia.

27. Location of old Hardy and Gould Wharves for packet ships. Until 1870 there was a broad and deep harbor here protected by an outlying beach, one half-mile in width upon which were located Massachusetts Humane Society "Huts of Refuge".

28 - 29 - 30 - 31 - 32 - 33 - 34 -- Shell mounds showing Indian Settlements - At 30 lived the last of the Indians in Chatham (About 1815).

35. Mischa Rafe, last of the Indians on Pleasant Bay lived here.

36. Zenas Nickerson's Salt-works

37. Loveland's Salt-works.

38. Joseph Loveland's Salt-works.

39. Sears Atwood's (and his sons' Joseph and John) Salt-works.

40. Richard Sears' and Isaac Hardy's Salt-works.

41. Enoch Howes' Salt-works.

42. James Hardings' Salt-works.

43. Thomas Howes' Salt-works.

44 - 45 - 46 - 47 - Ensign Nickerson's Salt-works.

47. The location of the last Salt-works standing in Chatham, (about 1880). These salt-works were used to make salt by evaporation from sea-water, the salt being used to cure fish. The discovery of Salt Mines and Wells at Syracuse, New York (about 1870) brought an end to this industry.

48. James Young's Salt-works.

49. Salt-works and flake-yards (prior to 1830) of Kimball and Levi Eldredge.

50 - 51 - 52 -- Former anchorages of fishing fleets. Fishing Industry was at its height about 1860.

53. Wreck of the ship "Owyhee" lost in 1826, earliest known total wreck in Chatham since Colonial times.

54. Here died Squanto (or Tisquantu) Indian friend of the Pilgrims who accompanied Governor Bradford here to buy corn from the savages in the autumn of 1622 and saved the Pilgrims from starvation.

Monomoy. Associated with these beaches are sand deposits that trail off into deeper water around the inlets at Nauset and Chatham Harbor and points south of Monomoy. These sandbars are large, move about erratically, and are a significant hazard to all boats. (Courtesy of the Eldredge Public Library.)

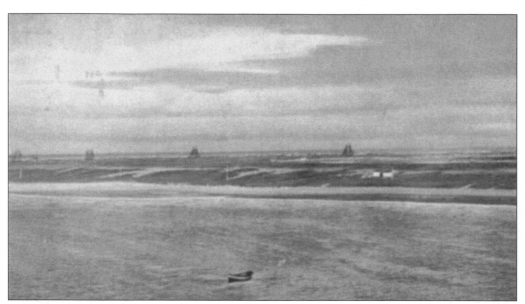

Until 1914 when the Cape Cod Canal was completed, to travel by ship near land from Boston to New York it was necessary to navigate through the complicated, shallow waters off Chatham. At one time in the 1890s, 365 sailboats were seen from the cliff by the Chatham Twin Lights during one day. The sea corridor off Chatham was the main highway. The coast was dangerous and very busy. (Courtesy of Donna Lumpkin.)

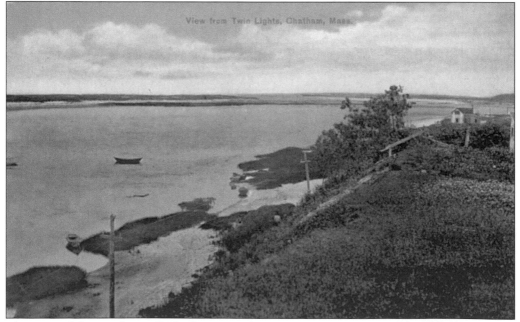

The story of the sandbars off Chatham, seen here from the Light around 1910, begins early in European history. The rudder of the boat carrying Samuel deChamplain in 1606 was damaged as it ran aground on the Chatham sandbars. Champlain mapped Chatham features during repairs made near Stage Harbor. Only a few years later, the Mayflower and the Pilgrims became entangled in the Chatham bars and turned north from their journey to Virginia, making landfall in Provincetown and eventually Plymouth. (Courtesy of Nancy Ryder Petrus.)

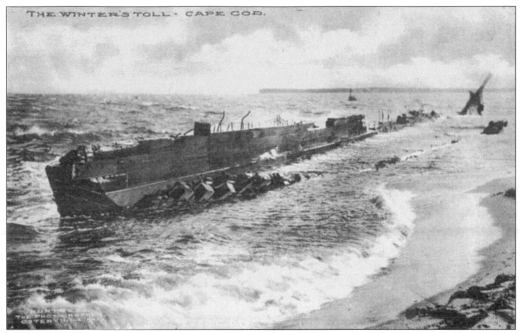

THE WINTER'S TOLL · CAPE COD.

Dozens, if not hundreds, of boats ran aground along the east shore of Chatham extending south to Monomoy Point. Each spring, the beach was littered with remnants of these boats and their sundry contents. Significant livelihoods in town were lifesaving and, of course, salvaging. (Courtesy of Wayne Gould.)

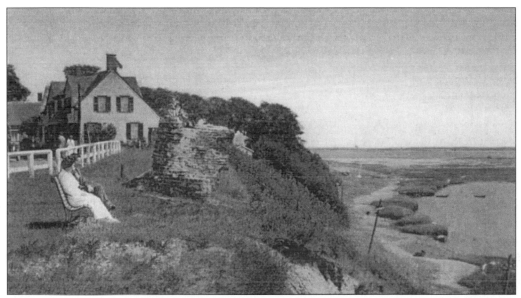

This early view from the cliffs in front of the Twin Lights shows salt marsh peat deposits on the beach at low tide. The peat deposits indicate that quiet water needed for salt marsh development had existed in front of the lights many years earlier, followed by rough seas that had eroded out the plants but not the peat. The inner harbor changed dramatically over time. The faint outline of the Old Harbor Station appears on the horizon. (Courtesy of Wayne Gould.)

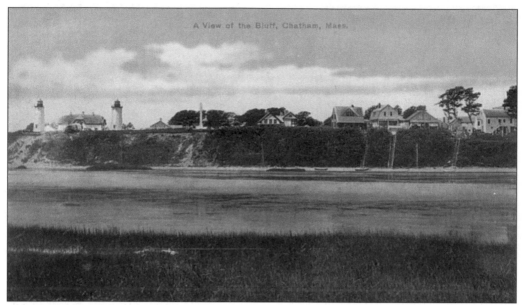

This view of the Chatham Twin Lights and a section of Main Street in about 1910 was seen by most ships passing by the Cape. At this time, the sand spit was much closer to the mainland and had been in this position for many years so that salt marsh had developed. The inlet into Pleasant Bay was north of this point and this section of the sand spit was accurately described as the South Beach.

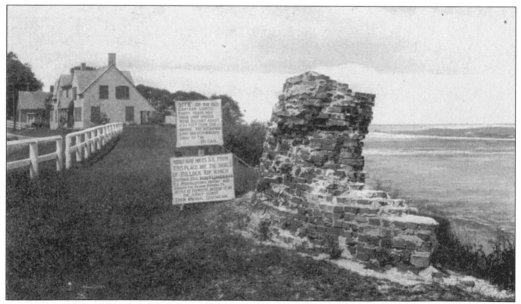

In 1877, a lasting inlet formed through North Beach during a winter storm. The inlet quickly widened, exposing the area near the lighthouses to waves from the open ocean. Over 200 feet of the bluffs eroded away in the next two years. The north tower of the lighthouse pair fell over the cliff in 1879, followed by the house and south tower the next year. The brick remnants of one of the towers was a tourist attraction for many years.

14

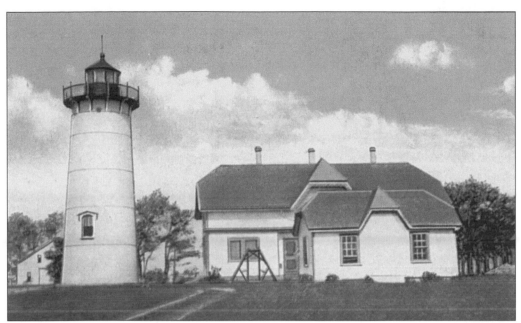

When the Chatham Lighthouses were electrified, it became possible to rotate the pair of beams and achieve the effect of a distinctive appearance for the Chatham Light without the need for two towers. When the Three Sisters Lighthouses at Nauset had to be replaced, it was decided to move the north lighthouse tower at Chatham to Eastham.

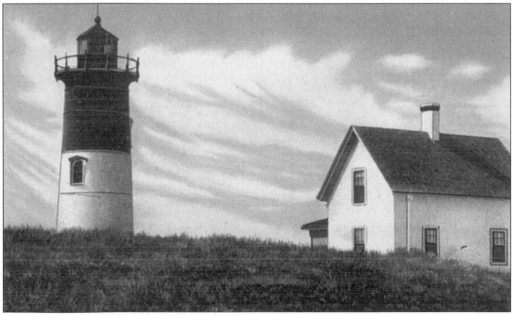

Nauset Light at Eastham is the former northern tower at the Chatham Twin Lights. In 1998, the old Chatham Lighthouse at Nauset was moved again, this time back from the edge of the eroding cliffs at Nauset.

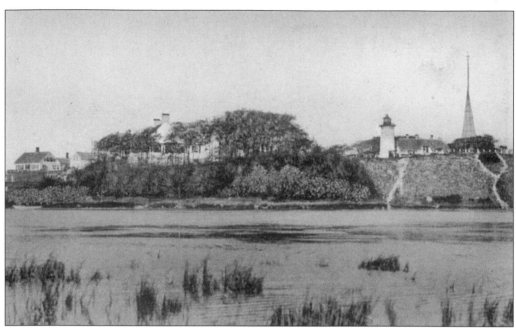

This view from the barrier beach shows the Chatham Light and Chatham Beach and Tennis Club in about 1930, with the new storm signal tower and paths from the cliff top to the beach. This almost 70-year-old view is very similar to what you might see today from a boat.

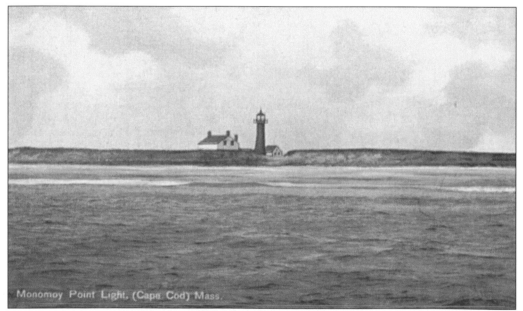

Monomoy Point Light. (Cape Cod) Mass.

Near the southern end of Monomoy Island, the Monomoy Lighthouse was constructed in 1823. A single beam, the Monomoy Light, was the first of a series of Cape Cod lighthouses coming from the south along the Outer Cape. The Monomoy Light was decommissioned in 1923 and used as a private home for many years, before being acquired by The Massachusetts Audubon Society.

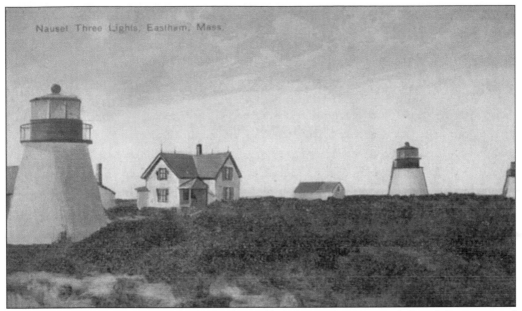

The Three Sisters at Nauset were the third set of lighthouses moving north from Monomoy and Chatham. These three short, crudely constructed rubble lights were moved several times before being replaced by the northern Chatham lighthouse in 1923. After a period of private ownership, the three small lighthouses were once again acquired by the federal government and are now a part of a display at the Cape Cod National Seashore.

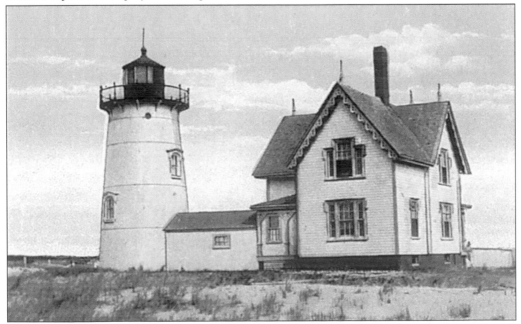

Harding's Beach Light, or Stage Harbor Light, was constructed in 1877 along the barrier beach on the west side of the entrance to Stage Harbor. The lighthouse is named for Joseph Harding, a local farmer who owned the beach. The lighthouse beam guided the commercial and recreational fleet and steamboat packets into the main harbor in Chatham. Decommissioned in 1933, the lighthouse is now privately owned.

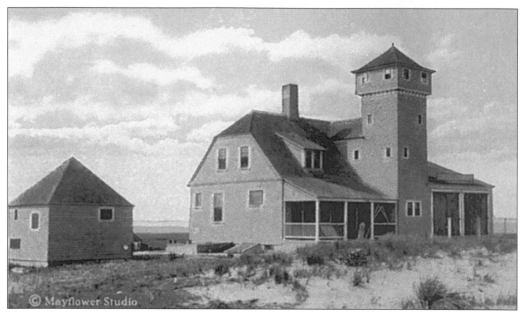

© Mayflower Studio

The lifesaving stations on Cape Cod were begun privately as the Massachusetts Humane Society in 1808. Shelters were constructed along the coast to aid stranded seaman and passengers. In 1870, Congress authorized the creation of the lifesaving system along the East Coast including the construction of a series of lifesaving stations. Old Harbor Station was built in 1898 at the south end of North Beach across from Minister's Point.

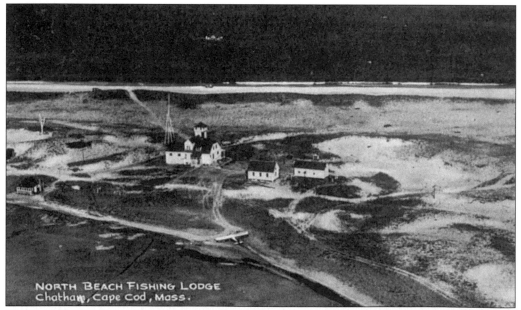

NORTH BEACH FISHING LODGE
Chatham, Cape Cod, Mass.

The Old Harbor Station consisted of a complex of numerous buildings, including housing for eight crew members, stables, boathouses, buildings for equipment, and later even for a seaplane. A small community of summer cottages developed in the vicinity of the station. Old Harbor Station was decommissioned in 1944, sold, and developed as a fishing lodge. The National Park Service reacquired the complex in 1962 when the Seashore was created. (Courtesy of Donna Lumpkin.)

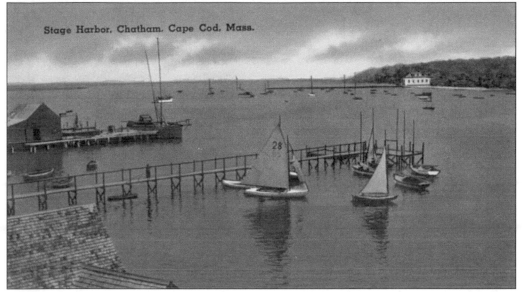

The Chatham Lifesaving Station, over time, was located at several points around Morris Island. This 1930s view shows the Coast Guard boathouse that is still present on Stage Island. The causeway to Morris Island is not present in this view. It was constructed in the mid-1950s to prevent sand from filling Stage Harbor from an inlet to the east. The causeway made Morris and Stage Islands accessible, and subsequently, both islands have been developed with large houses.

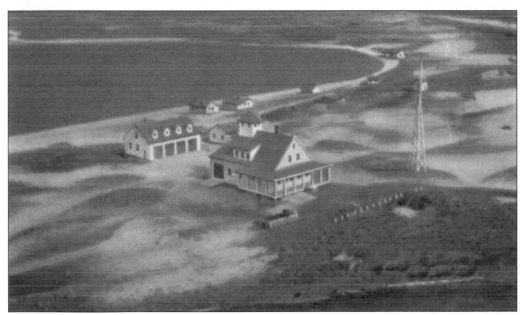

There were two lifesaving stations on Monomoy Island, one halfway down the island below Inward Point called Monomoy Station, and a second near Monomoy Point at the location of the old village of Powder Hole. The village was destroyed in a storm in the 1870s. The Coast Guard Station at Monomoy Point was a remote and lonely, but beautiful, outpost along the Atlantic. None of the buildings associated with the Coast Guard Station remain today.

The lifesaving stations were located about eight miles apart. Between each pair of stations, there was a small building constructed on the beach called a "halfway house." These buildings were outfitted with food, blankets, and material to build a fire so that beach-stranded people would not freeze to death. Every night through the winter, crew from the lifesaving stations would patrol from the station, meeting their counterparts at the halfway house before returning to their station. Until 1987, there was a halfway house on the beach near Andrew Harding's Lane. An example of a halfway house is preserved at the Mystic Seaport Museum in Mystic, Connecticut.

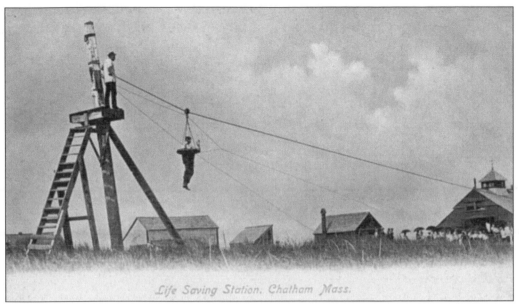

Life Saving Station. Chatham Mass.

The crews at the lifesaving stations were highly trained and required coordinated efforts to board stranded ships to save passengers and crew. This view of a lifesaving drill shows crowds of people witnessing a line transfer designed to connect a rescue vessel to a foundering ship—an operation called "Breeches Buoy." This scene is from the Chatham Lifesaving Station, east of Morris Island.

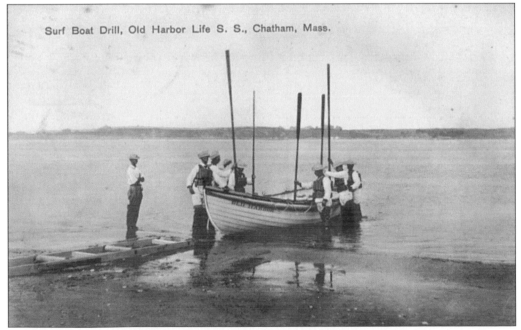

Surf Boat Drill, Old Harbor Life S. S., Chatham, Mass.

This view from North Beach, probably near the Old Harbor Station, shows the seven-man crew of the Old Harbor Lifesaving Station with Minister's Point in the background.

21

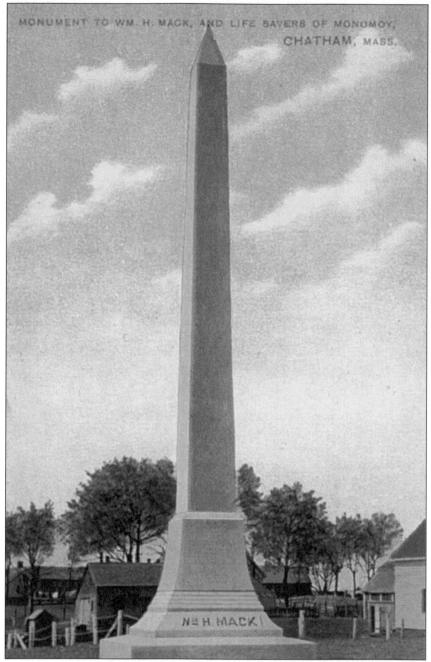

MONUMENT TO WM. H. MACK, AND LIFE SAVERS OF MONOMOY,
CHATHAM, MASS.

W. H. MACK

In 1902, the *Wadena*, owned in part by William Mack, ran aground on Stone Horse Shoal off Monomoy. The crew was rescued, but returned to salvage the contents of the ship. A storm came up quickly and the crew needed to be rescued by the Chatham lifesaving crew a second time. All crew on the *Wadena* died during the rescue and four of the five lifesaving teams also perished. Only one lifesaver survived. The mother and sister of William Mack, who died in the tragedy, paid for the construction of the Mack Monument in 1905 commemorating the brave effort of the Chatham lifesaving crew. The Mack Monument is located immediately north of the Chatham Light.

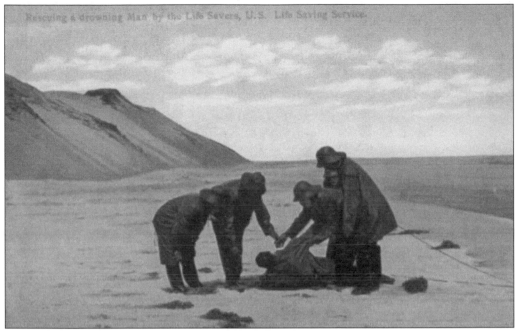

This view of five lifesavers rescuing a drowning man, who appears to be dead, has been labeled "Chatham," but it is probably from a site north of Chatham suggested by the high sandy cliffs. Over the years, the bodies of 106 unidentified seaman have been found along Chatham's beaches. They have been buried at town expense near the Mack Monument. There is a small commemorative stone inside a privet hedge just behind the monument.

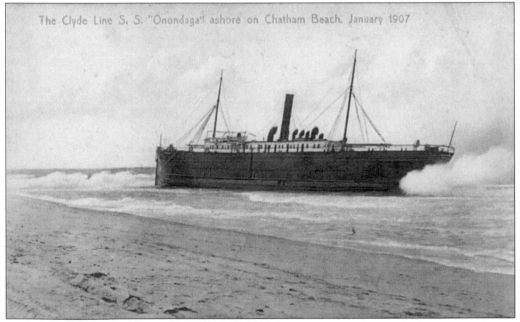

On January 13, 1907, the S.S. *Onondaga*, a cargo ship carrying goods from Maine to Florida, ran aground off North Beach just north of the Old Harbor Station. It was a major tourist attraction that summer, with many postcards showing the huge stranded ship.

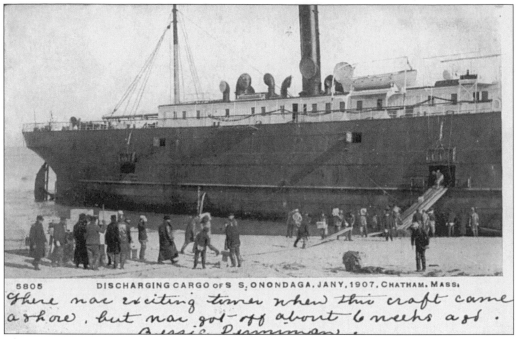

5805 DISCHARGING CARGO of S. S. ONONDAGA, JANY, 1907, CHATHAM, MASS.

There was exciting times when this craft came ashore, but was got off about 6 weeks ago.
Bessie Penniman.

The *S.S. Onondaga* was firmly anchored in the shifting sands of North Beach. Pairs of tugboats worked to pull the ship off the sand. Many people in the town assisted with the unloading of the *Onondaga* cargo to lighten the ship. There are stories of shoes, wrapping paper, and 25-pound bars of chocolate abundant in the town for several years.

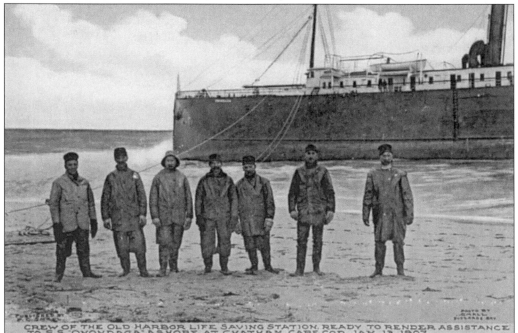

CREW OF THE OLD HARBOR LIFE SAVING STATION READY TO RENDER ASSISTANCE TO S.S. ONONDAGA ASHORE AT CHATHAM, CAPE COD, JAN. 13, 1907

By July of 1907, during a very high tide, tugboats were finally able to free the massive ship from the sand. Here the crew of the Old Harbor Lifesaving Station posed in front of the stranded ship.

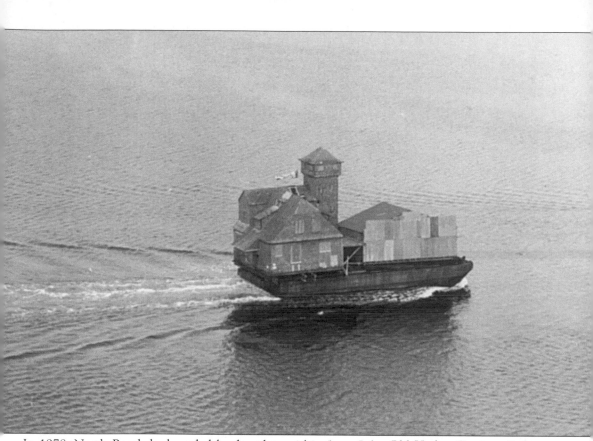

In 1978, North Beach had eroded landward to within feet of the Old Harbor Station. Only weeks before the ferocious February 1978 Northeaster, the Old Harbor Station was lifted by crane onto a barge for transport to Race Point in Provincetown. The lifesaving station spent the winter in Provincetown Harbor and was moved to its final destination on Race Point the following spring, where it is now a museum within the Seashore. The appearance of the silhouette of the Old Harbor Station on North Beach for almost 100 years has been lost forever. Chatham misses its lifesaving station. (Courtesy of Donna Lumpkin.)

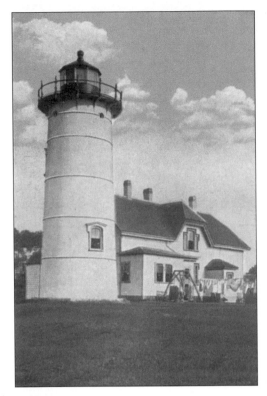

Chatham Light, in this card from 1923, looked very similar to the lighthouse today. It has always been not only a place of coastal protection, but also a home for crew members. This postcard is one of several showing laundry strung to the lighthouse keeper's house.

In 1944, Monomoy Island was acquired by the federal government and, in 1962, transferred to the new U.S. Fish and Wildlife Service. The federal government, during the creation of the Seashore, also acquired privately owned land on North Beach. Since the new inlet formed through North Beach in 1987, the barrier beach system south of the inlet, including the new South Beach and Monomoy Island, has been free of off-road vehicles. These beaches now support high concentrations of federally listed Piping plovers, nesting terns, gulls, and other shorebirds, and in the winter, Harbor seals and, occasionally, Gray seals.

Two

THE OLD VILLAGE

Tom's Neck and the Old Village extend from the harbor to Mill Pond, and from the Chatham Light to the intersection of Main Street and Shore Road. One of the first settled sections of Chatham, the region near the Chatham Light, recently referred to as the "Old Village," has remained a central feature of town. With dozens of old houses, the lighthouse, narrow streets, and great views of the Atlantic, no visit to Chatham is complete without a walk to the light or a tour of the streets between the harbor and Mill Pond. Even at night, the parking lot at Chatham Light has a constant flow of visitors watching the twin beams trace the barrier beach and a distant line along the horizon.

In 1905, the Old Village was already in decline as the business district, and shared the central functions of the town with the Main Street section that we now think of as the center of commerce. The heart of the town had earlier been farther from the coast, off Old Queen Anne Road near the pair of cemeteries at George Ryder Road.

In the mid-19th century, the commercial and social center of town moved to the vicinity of the Chatham Lights. The community clustered around the active wharves, warehouses, and fishing buildings of the harbor. Townspeople, more focused on the sea and commercial life, built snug houses crowded along Main Street, School Street, and Silverleaf Avenue with farms not far away. The Old Village was a thriving part of town with an active waterfront, numerous businesses, and the early components of tourism that would soon expand and dominate the culture of the town.

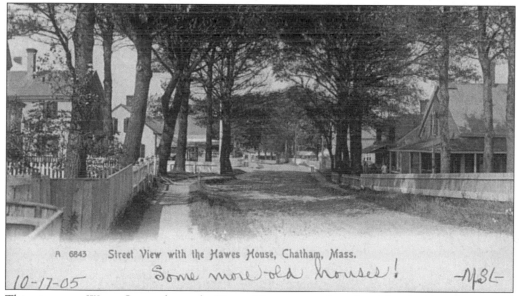

A 6843 Street View with the Hawes House, Chatham, Mass.
Some more old houses! -MSL-
10-17-05

This view near Water Street shows the Hawes House, second on the right, the Nautilus, second on the left, and in the distance on the left, the summer home of Heman Eldredge, father of H. Fisher and Marcellus Eldredge. The beach shacks at the base of the cliff in the Old Village were also known as "Scrabbletown," associated with the enterprising residents' rapid response to stranded ships, both to lend assistance when needed or salvage anything usable found on the beach.

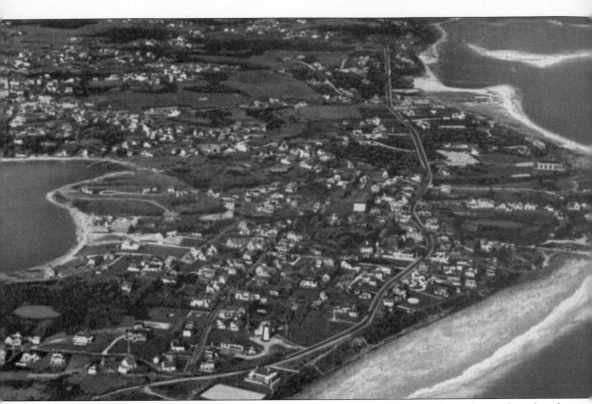

This early Richard Kelsey view, probably from the early 1940s, shows all of what is thought of as the Old Village of Chatham, extending from the lighthouse to Shore Road and from Mill Pond to the vicinity of the Cranberry Inn. The Old Village consisted of narrow streets on Tom's Neck near what had been the old center of town. This aerial includes Mattaquason Point to the right, which extended into Chatham Harbor, the Mattaquason Hotel, the Marcellus Eldredge Mansion at Watch Hill, and structures at the end of Holway Street and Andrew Harding's Lane. All of these features have now been either torn down or lost to recent shoreline erosion. (Courtesy of Wayne Gould.)

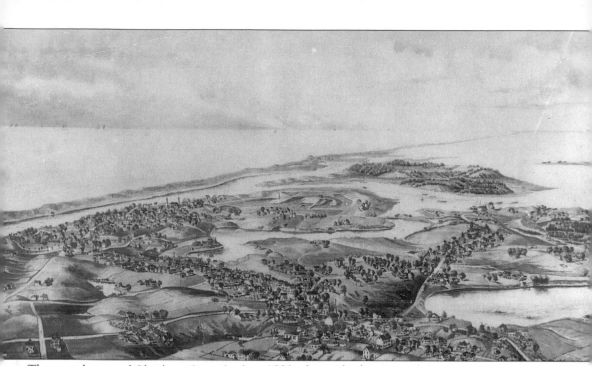

This aerial view of Chatham from the late 1800s shows the location of the major features in town. The barrier beach runs along the east shore of town with the Chatham Lifesaving Station complex across from Morris Island. The Old Village is located near the pair of lighthouses. The center of town along Main Street is in the lower middle part of the view. Mill Pond is in the center and Oyster Pond to the right. No point in town is very far from water. (Courtesy of the Eldredge Public Library.)

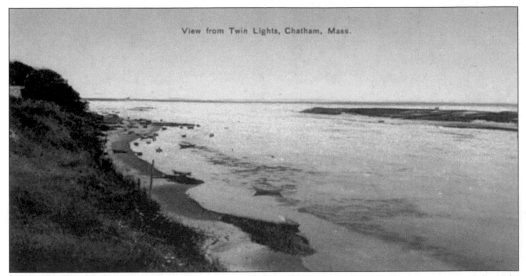

Looking north from the cliff in front of Chatham Twin Lights to the faint silhouette of the Old Harbor Station on North Beach, the waterfront along the Old Village was still an active place in 1905. This view shows electric poles and a road at the base of the cliff extending to the lifesaving station at Morris Island and Monomoy. There were buildings on the beach at Andrew Harding Lane and remnants of warehouses at Water Street. Between 1920s and 1950s, "Good Walter" Eldredge lived on the beach and was a well-known local character with his house built of old shipwrecks.

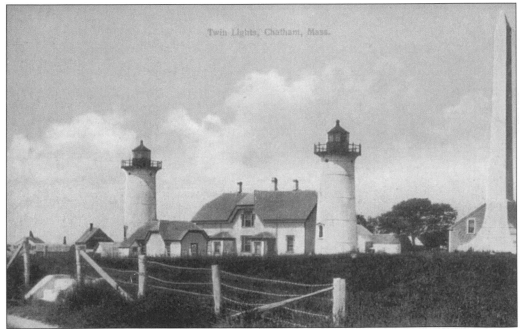

Twin Lights, Chatham, Mass.

Chatham Twin Lights was really the main destination for visitors to the Old Village. A revolving single beam replaced the twin beams of the lighthouses in 1923, with one beam running the line of North Beach and the other pointed far out to sea. Numerous postcards were made of this view, such as this 1910 card by Dickerman.

30

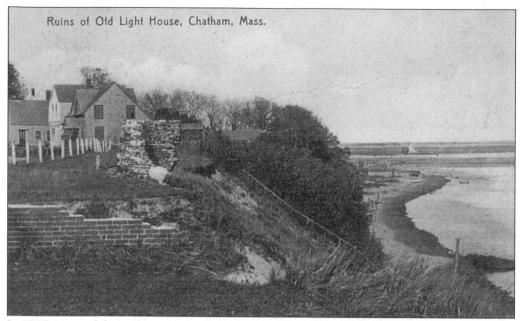

Ruins of Old Light House, Chatham, Mass.

In 1905, some of the earliest postcards of Chatham focused on the ruins of the Chatham Lights and lighthouse keeper's house. These piles of brick were present in various forms up until the 1960s when the current parking lot was constructed and the last remnants of the lighthouse were finally gone. Many local residents have small mementos of these old lighthouses.

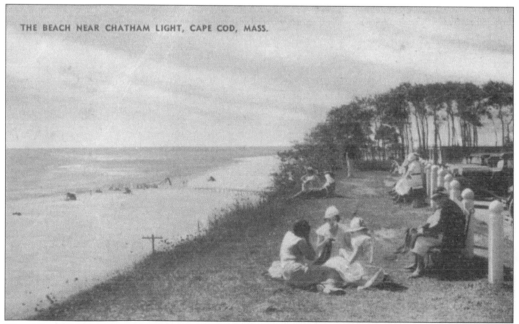

THE BEACH NEAR CHATHAM LIGHT, CAPE COD, MASS.

The Chatham Lighthouse cliffs were a popular meeting place. These picnickers in the 1930s were drawn to the spectacular views of the Atlantic. Note the faintly visible boardwalk that extends across the beach, constructed for access to the water from the new Chatham Beach and Tennis Club.

In 1928, the Chatham Beach and Tennis Club was built eastward of the Chatham Twin Lights on one of the last high points of ground in the Old Village. Displacing several earlier buildings, the Beach and Tennis Club had a commanding view of the Outer Beach.

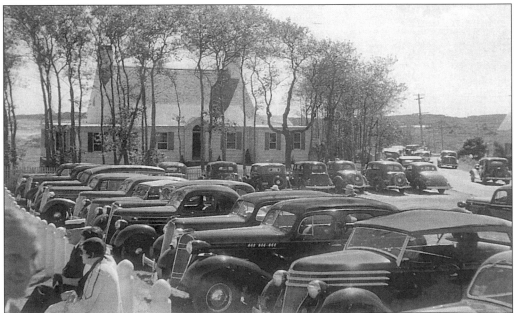

The Beach and Tennis Club was an extremely popular social club, an alternative to sailing and golf, which were also very popular in Chatham. The wind-pruned trees are silverleaf poplars introduced to Chatham in the early 1800s. They still grow wild throughout the Old Village. Silverleaf Avenue was named after these trees. A few of these trees are still present at this location.

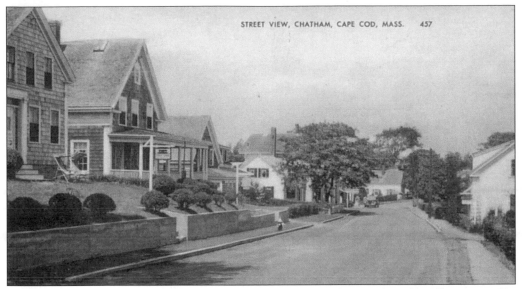

Between 1905, when postcards first appeared in Chatham, and 1940, the Old Village was still a major commercial part of town. The building on the right side of this postcard, at the head of Andrew Harding Lane, was the Tuttle Meat Market, later a guesthouse, The Whistling Whale, and now a private home. The white building with the tall chimney was the John Hallett Store, now the Calico Cat Gift Shop. The second building on the left was also a guesthouse, The Ship's Bell. (Courtesy of Wayne Gould.)

The Little Tavern was located at the corner of Main Street and Hallett Lane. Constructed in the 1920s after an earlier building had burned at the site, The Little Tavern was an ice cream shop. Later it became a restaurant, The Port Fortune, and more recently a bed and breakfast, The Port Fortune Inn. While the building has been expanded and the roofline changed several times, the small southern section of the building is still recognizable today. John Hallett's Store is in the background. (Courtesy of Wayne Gould.)

In 1840, John Hallett built a store for his wife, Charlotte, attached to a "Cape half-house" at the corner of Hallett Lane and Main Street. The store included a Greek Revival facade with pillars imported from Spain, Victorian detail, and a widow's walk that was lost during a hurricane. Originally a dry goods store, the Hallett's building has been an ice cream shop, an antique shop, and more recently, The Calico Cat Gift Shop. The original shelving and Victorian interior detail are still present in the store. This shop and a small art gallery near Chatham Light are the only two stores left in the Old Village.

The real center of the Old Village was, for many years, Andrew Harding's Store. The bench in front of the store was a frequent gathering place for local men who told stories of old Chatham. Joseph C. Lincoln, local author of over 50 Cape Cod books, was a regular visitor to this bench. Many of his story lines are believed to have originated from conversations with these Chathamites. Andrew Harding died in 1919, but the store was maintained until the 1940s when it was sold and became a private home. Today, this building is on the northwest corner of Main Street and Wilderwood Lane. It has been turned so that the side of the old store faces the street. It is barely recognizable as the old Harding store. A plaque commemorates its past role in the Old Village. (Courtesy of Joseph Nickerson.)

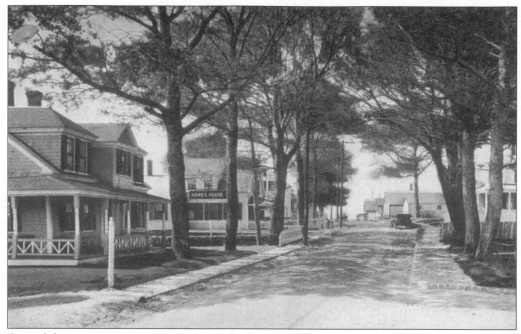

One of the most common postcards in Chatham was the Hawes House, the building with the pair of dormers. Within a block of Chatham Light, the Hawes House was a private home that began to take in visitors at the turn of the century offering a room and breakfast. The main building was expanded and additional bedrooms were constructed in two buildings along Water Street toward the water. Many of the homes in the Old Village became seasonal guesthouses at that time. Note the curbing along the street across from the Hawes House. It was constructed of Belgian blocks, which were used as ballast in ships that visited Chatham. These granite blocks were off-loaded to make room for local cargo. Many of the homes of the Old Village still have Belgian blocks scattered around their foundations and in their gardens.

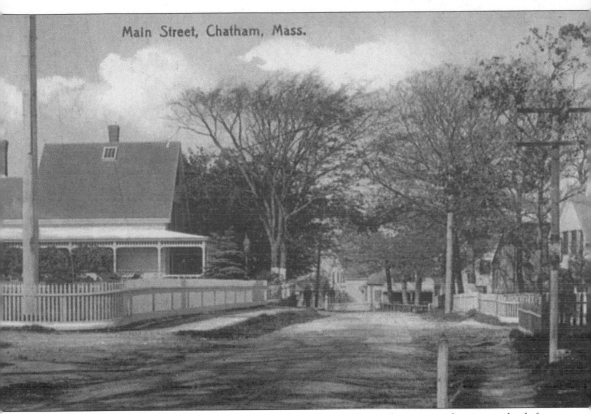

Main Street, Chatham, Mass.

This view of Main Street looking north from Water Street shows the summer home on the left of Heman Eldredge, father of H. Fisher and Marcellus, both major developers and patrons of Chatham. Heman Eldredge owned a successful brewery in Portsmouth, New Hampshire, and spent his summers in Chatham. At the back of the property was a building built in New Hampshire and transported to Chatham by boat. The first floor was a barn. The second floor was "The Temple of Reason" where Mrs. Eldredge held temperance meetings. The building blew down in a storm in the 1950s. The Eldredge summer home is now known for its large lawn, huge copper beech, and an American flag painted on the house wall under the front porch roof.

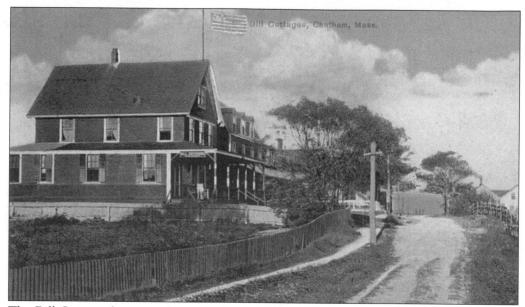

The Dill Cottage, known today as the Surfside Inn on Holway Street, has been a guesthouse since this postcard view in 1910. The Surfside was constructed from three buildings moved to make room for the Marcellus Eldredge Mansion at Watch Hill just down the street. Marcellus Eldredge was married to Mary Dill. Ironically, the Surfside Inn has recently been remodeled and is a successful guesthouse, while the Eldredge Mansion was torn down in 1941.

The small cottage on the left is on Dill Street, now known as Holway Street. It was built around 1800 and is a classic example of a "Cape half-house." Across the street was the Rhode Island House which began as a guesthouse in 1886. It was also known as the Indian Rubber House, because it could be expanded to accommodate seemingly unlimited numbers of people. This postcard was reproduced for many years both with and without telephone poles, and with the horizon moved several times upward to enhance its coastal appearance.

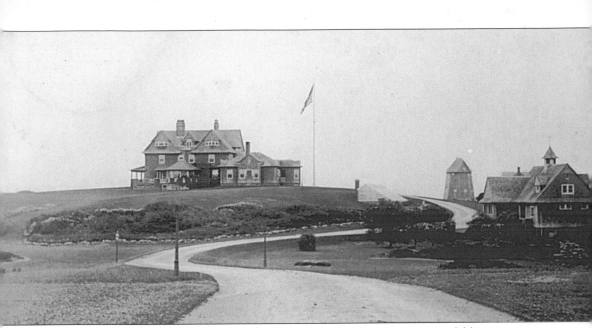

In 1886, Marcellus Eldredge returned to Chatham after many years as a successful businessman in his father's brewery in Portsmouth, New Hampshire. His father's summer home was at the corner of Water and Main Streets. Marcellus Eldredge constructed his elegant home on Watch Hill at Mattaquason Point with commanding views of the harbor and North Beach. The estate included a carriage house and windmill shown on the right side of this postcard. After the mansion was torn down in 1941, the estate was sold for residential development. The carriage house and windmill were renovated into private homes.

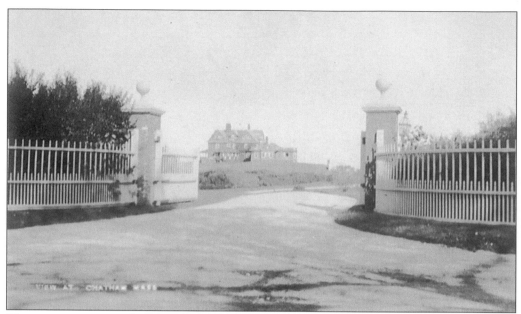

The entrance gate to the Marcellus Eldredge home consisted of two brick pillars topped with wooden balls and an ornate fence. This entrance gate is still a prominent feature of Main Street at its junction with Shore Road.

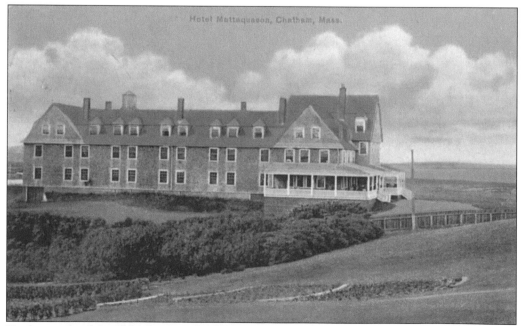

To the north of the Eldredge Watch Hill Estate was the Mattaquason Inn. Constructed first as the Dill House by Marcellus Eldredge and named after his wife's family, it was sold and expanded it into a grand, shingle-style hotel with living rooms, a dining room, and a large porch. There were also a series of cottages.

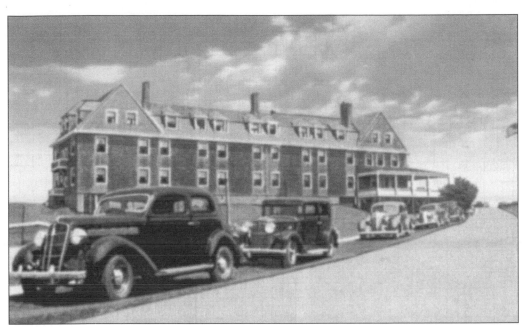

Beginning 18 years before Chatham Bars Inn, the Mattaquason was the elegant Chatham summer hotel for large families to take up residence for most of the summer. Located at the end of Mattaquason Point, the Inn had wonderful views of Chatham Harbor and the Outer Beach. This was a place for weddings, summer parties, and long afternoons on the beach. It was an all-inclusive destination for its clientele, with all meals and entertainment provided on site.

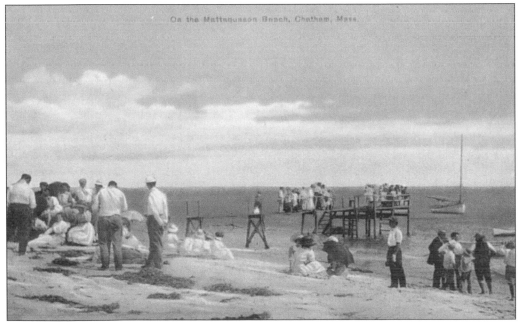

In front of the Inn was a pier that appeared in several early postcards. The pier was used for boat excursions to the Outer Beach and to Monomoy south of town. It must have been hot on the beach with so many clothes. Summers were hot in general, but cooler in seaside Chatham than in the rest of the Northeast.

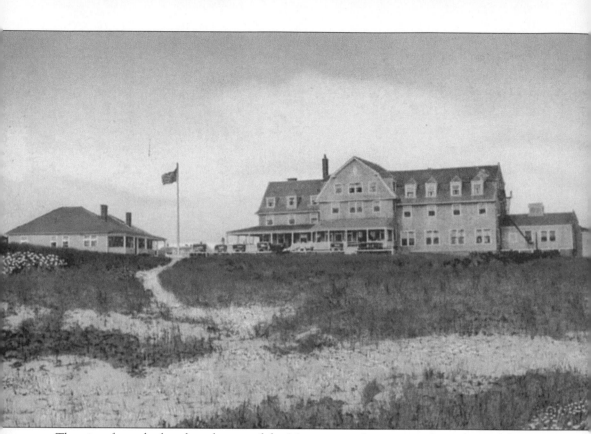

The view from the beach and water of the Mattaquason Inn was nearly unchanged for over 60 years. Imposing and solid on its point into Chatham Harbor, the inn was difficult to maintain, needing nearly constant upkeep. The loss of the Inn in 1956 resulted from the need to renovate the entire structure at a time when cottages and motels were more popular and most visitors were unable to spend the entire summer at a resort. Large private homes similar to others along Shore Road replaced the old inn. The character of the southern end of the harbor had changed forever.

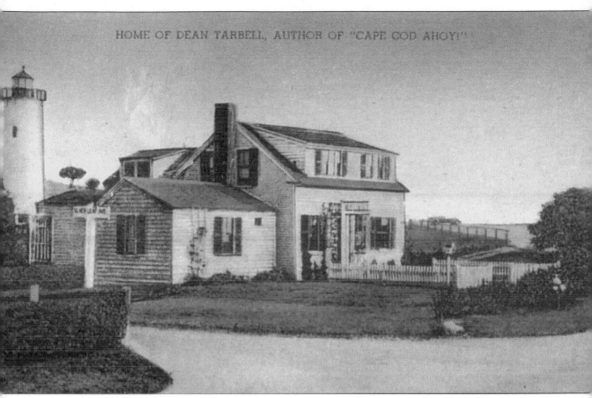

At the corner of Silverleaf Avenue and Main Street was the home of Arthur Tarbell, who was dean of students at the Carnegie Mellon Institute. Dean Tarbell retired to Chatham in the 1930s and wrote two books that became well known on the Cape, *Cape Cod Ahoy!* and *I Retire to Cape Cod*. These books captured some of the anecdotal stories of Cape Cod, as well as the increasingly common experiences of retirees coming from Off Cape to their new homes by the sea. The Tarbell House had been moved earlier from across the street in the location of the Chatham Beach and Tennis Club. Dean Tarbell turned the house on its axis so that the front faced the view to the east.

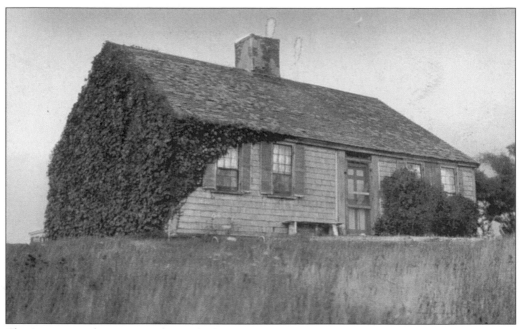

The Ivy-covered Cottage is located off Water Street on Hammond Lane in the Old Village. This building is an example of a "full Cape," with a front door flanked on both sides by a pair of windows. The building is typical of those in the Old Village in that it has had multiple uses. At one time, in the 1930s, it was a lending library run by Gwen Grimmer. This cottage was the subject of several postcards.

The scene from Chatham Light offers a memorable image of the area with its broad beach, protected harbor, and distant barrier dunes. This view from the 1940s remained nearly unchanged until the mid-1980s when a new inlet formed through North Beach about one mile north of Chatham Light. This section of North Beach is now within the wide inlet and open to the ocean. The new channel into Chatham Harbor runs very close to the beach below the lighthouse cliff.

Three
STAGE HARBOR

Stage Harbor was first named Port Fortune by Samuel deChamplain who visited this safe anchorage in 1606 during the early exploration of Cape Cod. Champlain's ship anchored in the harbor. Since then, Stage Harbor and Mill Pond nearby have been the scene of many of the marine events in town. With a connection to Nantucket Sound, the harbor has been the focus of commercial fishing and shipping in the Sound extending toward Hyannis and points west along the coast.

During the 19th century and into the 20th century, the waterfront was active with warehouses, piers, a Lifesaving Station, and anchorage for numerous boats. By 1905, coastal recreation was seriously underway. The harbor was crowded with sailboats with easy access to Monomoy and southward to Nantucket and Martha's Vineyard. The Mitchell River Bridge, Bridge Street, the Old Mill, piers, warehouses, and lifesaving station were images of seacoast life and old Chatham that stayed with the new visitors arriving by the thousands in the early 20th century.

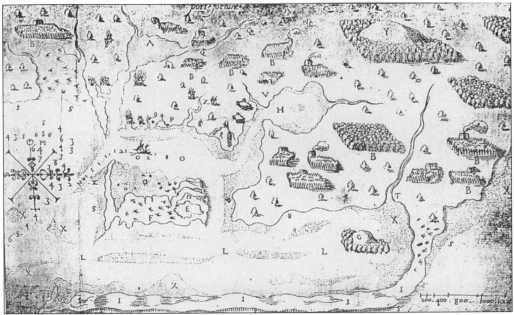

In 1606, Samuel deChamplain visited Chatham while mapping the east coast of Cape Cod for the French Government. The rudder of his boat was damaged near Monomoy. His ship entered Stage Harbor for repairs. He came ashore at the corner of Stage Harbor Road and Champlain Road and christened the harbor Port Fortune. After several days of interacting with local Indians, the French developed unfortunate misunderstandings with their hosts and four Indians were killed along with three members of the French crew. Port Fortune may have been misnamed. During this short visit, Champlain produced the first detailed map of Chatham.

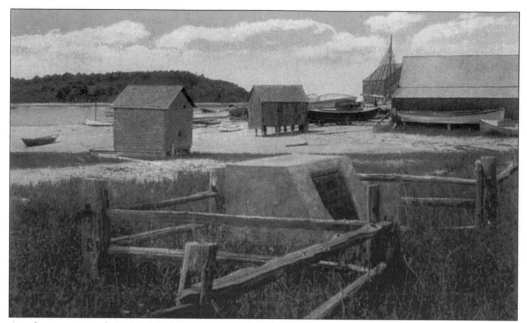

At the corner of Stage Harbor Road and Champlain Road, there is a small monument commemorating the landing of Champlain's ship at Port Fortune. In the background are fishing shacks, warehouses, and Stage Island. The brass plaque was stolen in the 1950s and replaced by a heavy granite block with engraved letters, making it harder to steal.

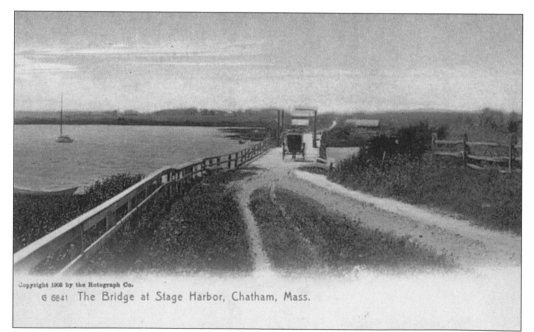

Copyright 1905 by the Rotograph Co.
G 6841 The Bridge at Stage Harbor, Chatham, Mass.

Mitchell River Bridge connects Tom's Neck with the main part of Chatham. The Mitchell River Bridge was built in 1854 and named for William Mitchell, who was the first to live along the west shore of the river. Until that time, the south side of Tom's Neck was a remote part of town. The bridge has always been a drawbridge to allow larger boats to enter the Mill Pond.

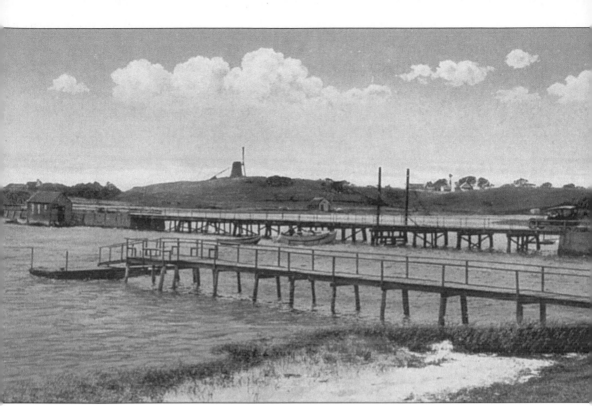

The Old Windmill overlooked the Mitchell River Bridge and the Mill Pond. One of six early windmills in Chatham, the Mill on Crocker Rise was often photographed for postcards. It was moved from this location in the early 1950s.

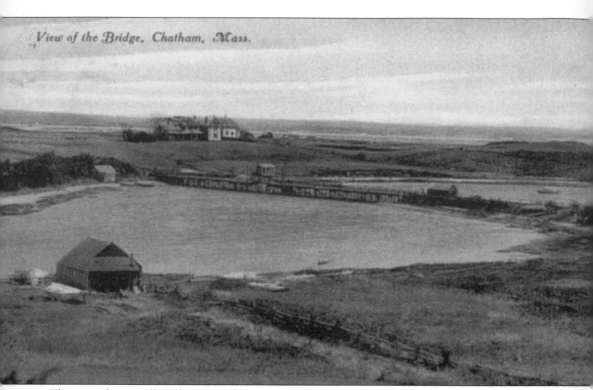

View of the Bridge, Chatham, Mass.

The view from Mill Hill, now called Crocker Rise, and the Old Windmill looking east shows the Mitchell River Bridge and the Monomoy Inn. This mansion, now painted yellow, has been owned by the Baker Family for the last 50 years, and houses members of the Monomoy Theatre. Originally a farmhouse, the building was expanded several times and was mainly used as a sportsmen's lodge for hunting and fishing. Note that there are no other buildings on the horizon, which today has scattered houses at the south end of Little Beach and along Morris Island Road.

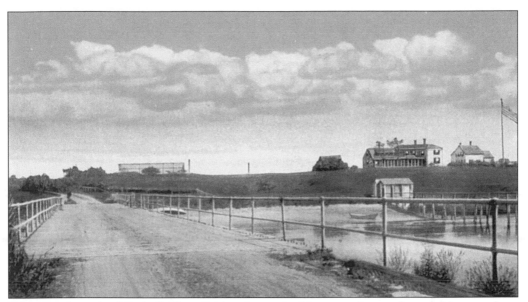

The view from the Mitchell River Bridge shows the Monomoy Inn and a tennis court along Bridge Street, which was still a dirt road in the early 1920s. The entire area was grazed or mowed leaving it completely open. Today this same view is dense with shrubs and small trees and is mainly a part of land owned formerly by the J.S. Johnson family, now owned by the Chatham Conservation Foundation.

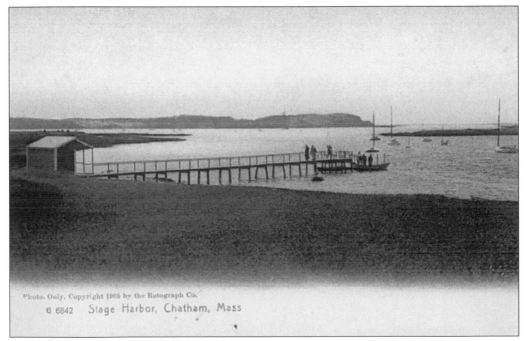

Photo. Only, Copyright 1905 by the Rotograph Co.
G 6842 Stage Harbor, Chatham, Mass

The view from the Monomoy Inn pier on the east side of the Mitchell River Bridge was also frequently photographed, looking across Stage Harbor to Stage Island and the harbor outlet to Nantucket Sound.

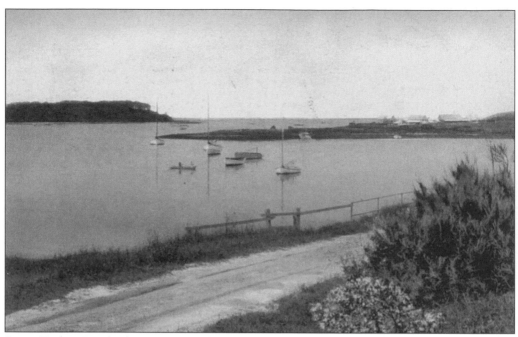

Stage Harbor Road, along Stage Harbor, was little more than a sandy path with spectacular views of the quiet harbor, Stage Island, and the fishing buildings at Champlain Road.

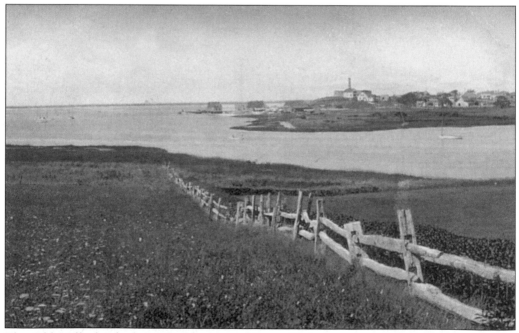

The Old Mill also had wonderful views of Stage Harbor across to Champlain Road. The smokestack was a part of the freezer plant built around 1912 to store fish. The faint silhouette on the horizon is the Harding's Beach Light.

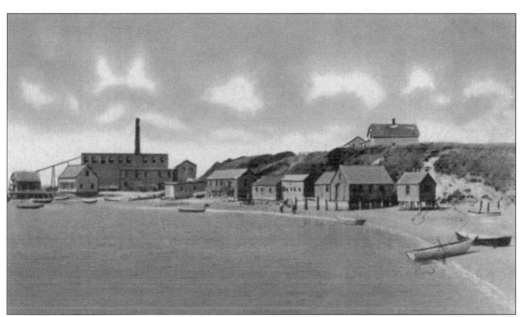

At Champlain Road, clustered around the freezer plant, were a series of fishing shacks, a sail loft, and warehouses. The freezer plant was last used for cranberries. It burned in the 1970s. (Courtesy of Donna Lumpkin.)

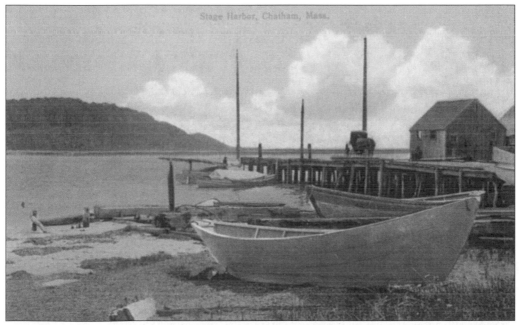

This pier at Champlain Road was where the packet steamboat with service from New York, Nantucket, and New Bedford came into Chatham. Even boats from Boston occasionally made the dangerous trip around Monomoy into Stage Harbor. There was regular steamboat travel to Chatham for passengers and cargo until 1896. Railroad service to Chatham displaced transportation by water.

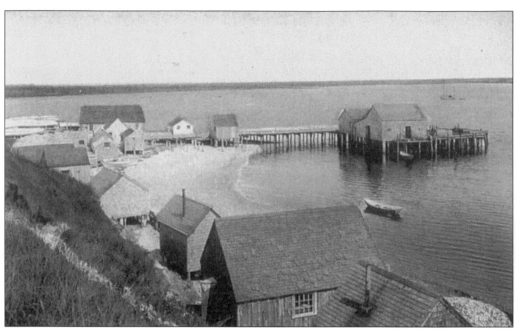

The fishing shacks and the steamboat pier were crowded around a point near the outlet of Stage Harbor, as seen from the heights on Champlain Road.

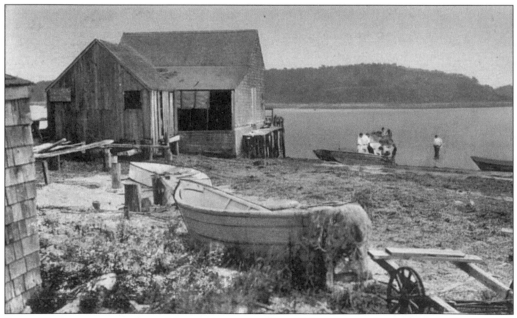

Stage Harbor was popular with tourists, as well as fishermen and merchants. There were occasional excursion boats from the pier to Stage Island and points along Monomoy.

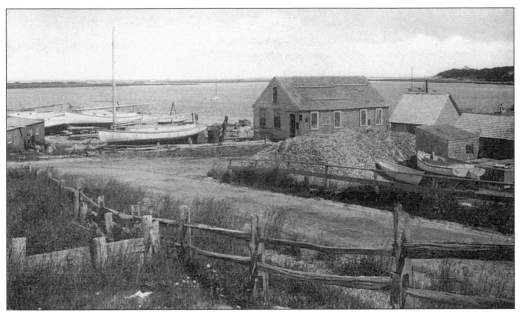

As today, Stage Harbor has always been a working harbor. Boats out of Stage Harbor mainly fished in Nantucket Sound. There is a large pile of scallop shells in the center of this photograph. Scallops were shucked from the shell at the wharf, and the shells left in a huge pile to decompose. In the distance are Morris Island and the east side of Stage Harbor.

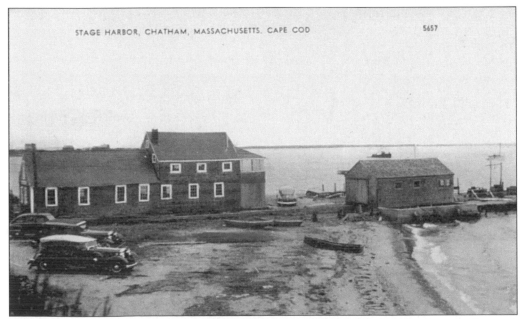

This view of Stage Harbor in the 1940s shows one of the fish houses that was later to become the Harbormaster's office. Today this building is in poor condition and is about to be torn down.

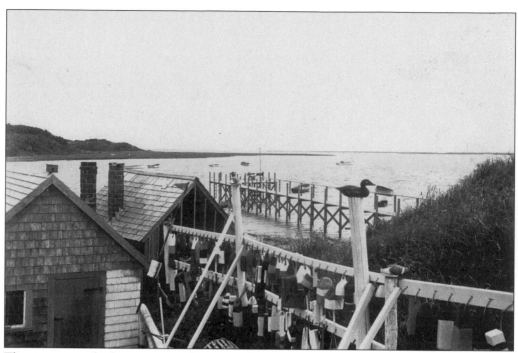

The picturesque harbor was a popular tourist destination in its own right. Brightly colored buoys and decoys decorated this fishing shack along the harbor's edge.

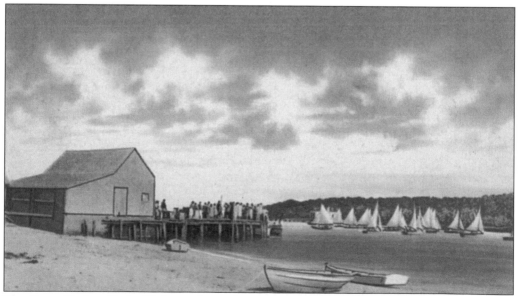

The Stage Harbor Yacht Club was located in a complex of buildings on Champlain Road. A small fleet of sailboats raced on a course through the harbor on Sundays throughout the summer. These races still take place in the busy modern harbor.

Four
MAIN STREET

For over 100 years, Main Street has been the central artery of Chatham, connecting the roads from Harwich, Orleans, and the train station to the waterfront near the lighthouse and, by the early 1900s, to the hotels along the coast. Mill Pond and Oyster Pond lie nearby and Stage Harbor is only a short distance away. The Chatham churches, town hall, the Eldredge Public Library, major businesses, the school, and the post office were scattered along Main Street.

By 1905, the central section of Main Street from Old Harbor Road to Chatham Bars Avenue shared the commercial life of town with the waning businesses of the Old Village. Like all New England towns, a white-steepled church dominated the village center whose main street was lined with tall trees matured from town beautification projects initiated after the Civil War.

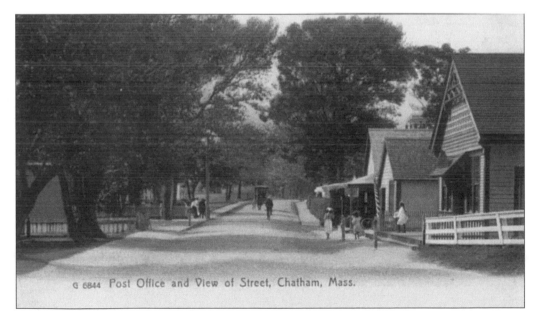

G 6844 Post Office and View of Street, Chatham, Mass.

By 1905, the commercial center of the town was firmly established in the section of Main Street stretching from around Chatham Bars Avenue to just west of the current rotary. The post office was located at the east end of this section of Main Street where the Tale of the Cod is today. Mail was brought to Chatham by the railroad from Harwich and was transported by horse to the post office for sorting and distribution.

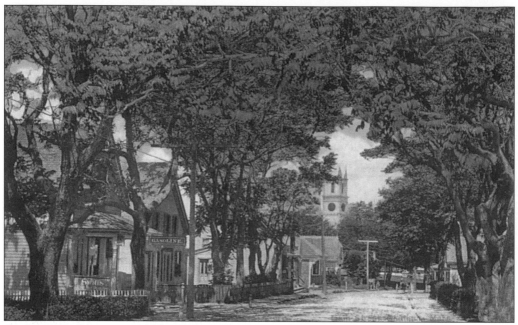

At the turn of the century, Main Street Chatham was a green and inviting place. Following the Civil War, efforts were made in all village centers to plant trees to create a park-like setting for the commerce of town. After 40 years, the maples along Main Street were mature and not yet severely battered by coastal storms. The Methodist Church tower was a frequent feature of many of the Main Street cards.

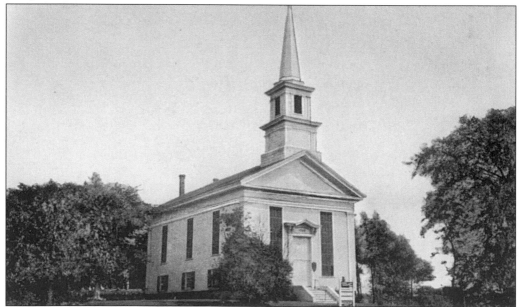

The Congregational Church is always one sort of center in a New England town. It is no different in Chatham. The Congregational Church was moved in 1866 from the Union Cemetery about a mile to the west to its current location. Earlier the church had been the center of both political and religious life. Separated early in Chatham history, the town offices and church were initially housed in the same building.

This often-reproduced postcard of the Methodist Church illustrates another part of the historical postcard story. Those that produce cards don't always know their subject well. This card of the Methodist Church was labeled the Congregational Church. Undeterred by the error, the manufacturer simply crossed out the mistake and wrote the correct church name in white lettering and then produced another quantity.

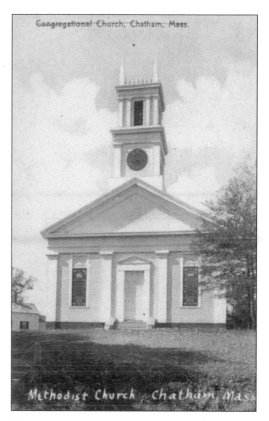

Congregational Church, Chatham, Mass.

Methodist Church, Chatham, Mass.

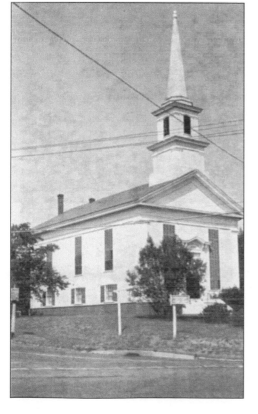

The Congregational Church tower was a dominant part of the town profile. When a lightning storm destroyed the tower in 1877, a replacement tower was constructed from the mast of the bark *R.A. Allen* recently wrecked off Monomoy. Chatham ingenuity found all sorts of ways to use material at hand in a crisis. The electric wires were not removed from this card as they were from most of the early Chatham village cards. On many postcards, the wires were easily painted out in the coloring of the finished card.

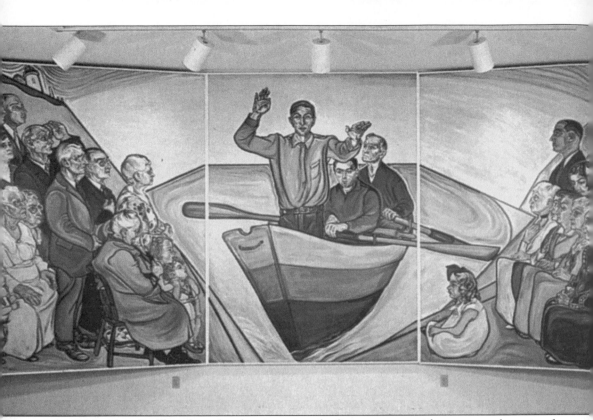

In 1932, Alice Stallknecht, a local artist, painted religious scenes with townspeople posing for figures in the paintings. All of the characters in religious allegories were highly recognized members of the town. Some in town were offended by what was seen as an irreverent representation of Jesus in town scenes. The paintings were displayed in the vestry of the church and then consigned to an unheated building. The building was salvaged from the discontinued railroad station and moved to a field near Stage Harbor. In 1970, the paintings were restored and with the old building moved to the Atwood House Museum complex where they are on display today. (Courtesy of the Chatham Historical Society.)

Summer visitors and an influx of new year-round residents organized a Catholic church in the late 1800s. The Holy Redeemer Church was built off Highland Avenue near Main Street in 1915. The gray shingle church has changed very little over the years.

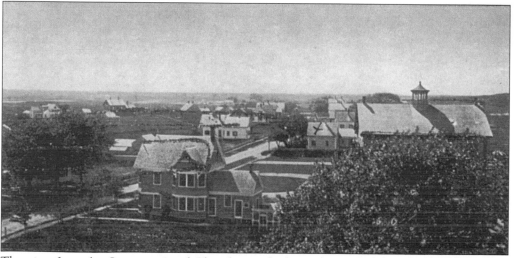

The view from the Congregational Church steeple shows the roof of the town building and a skyline nearly uninterrupted by trees. The Queen Anne Inn appears along the horizon on the left with its two chimneys and a faint sliver of Oyster Pond is farther to the left. The Victorian house in the foreground, owned by George Snow, was torn down and later replaced by the Mobil station.

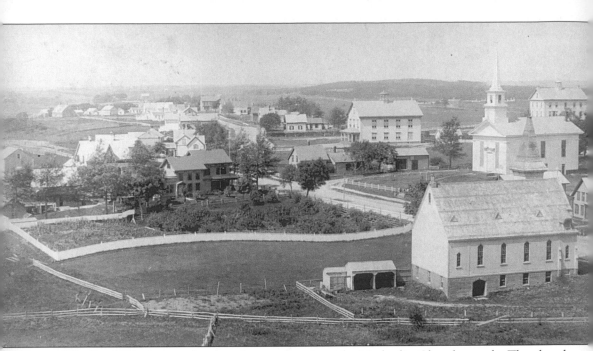

This late 19th century photograph was taken from the Methodist Church steeple. The church in the foreground is the Universalist Church. The Congregational Church is in its current location across the street along Old Harbor Road, which was then a dirt road. To the left of the Congregational Church is the town building that burned in 1919. To the right rear of the Congregational Church is the high school. Many of the buildings in this view are no longer present. At this time, Chatham was still a very rural town with fences to control animals throughout the village center.

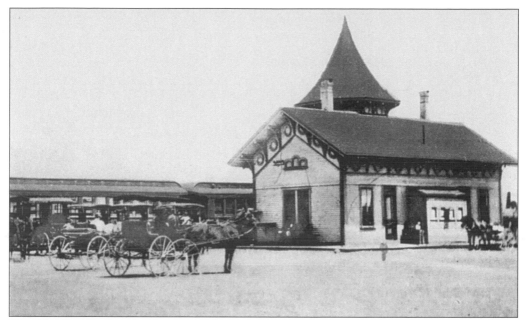

The Chatham Railroad Depot was built in 1896 at its present location when Chatham was the last town on the Cape to get rail service. Rail travel for passengers and freight quickly became the standard. It was a 13-minute, 7.7-mile journey from Harwich to Chatham. The arrival of the train increased the efficiency of travel to Chatham and proved a boon to tourism. (Courtesy of Donna Lumpkin.)

There were three railroad stops in Chatham. The first stop was the South Chatham Station, connecting the small village with the larger villages of Chatham and Harwich. High school students in South Chatham were able to attend school in Chatham which was only a short walk from the depot. There was a station at West Chatham for only a short while, principally serving passengers going to the Hotel Chatham in Chathamport. A hard-seated wagon met these passengers and bounced the final four miles to the hotel. (Courtesy of Donna Lumpkin.)

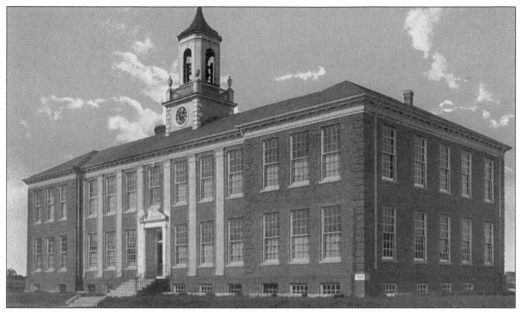

After the town offices burned in 1919, Chatham decided to build a new town building combining the offices with a new school. The Chatham School was built in 1924 and included space for the town offices with a two-cell jail in the basement. Parts of the old school were moved to the back of the new building. The Chatham School served the town for 64 years before becoming obsolete. There is currently a debate about the fate of the old building.

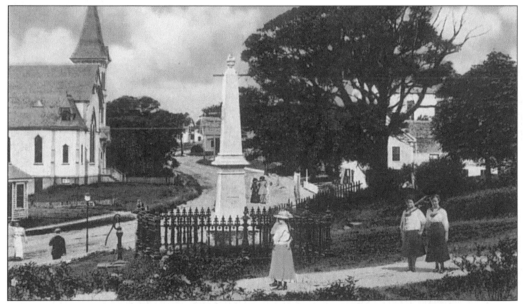

At the junction of Seaview and Main Streets is Sears Park, given to the town by Richard Sears who owned a home nearby. A war monument commemorating Chatham men lost in the Civil War was erected in 1869. The monument is engraved with the names and stories of the death of 24 Chatham men. With a population of only 2,700 in 1860, Chatham sent 292 men to the war. The town pump also appears in this view. The church is the Universalist Church, now the Episcopal Church. (Courtesy of Wayne Gould.)

By the 1920s, the wrought-iron fence had been removed from the monument and gardens were beginning to replace the town pump. Today the small park is a colorful centerpiece of downtown Chatham.

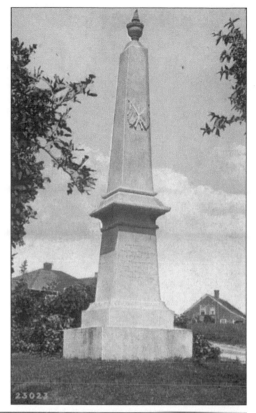

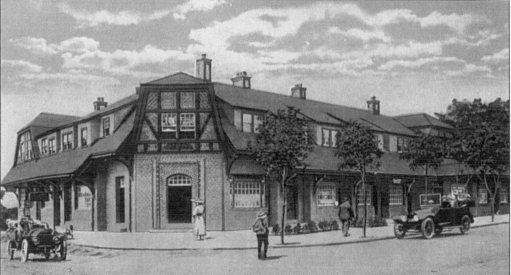

In 1915, the Brick Block was built by the Chatham Associates, a group of businessmen who also constructed Chatham Bars Inn, the bowling alley on Chatham Bars Avenue, and large rental houses on the Mill Pond. The Brick Block was a commercial building to house the new post office and the first offices of the Chatham Trust Company. The structure was modern and efficient with apartments on the second floor. The Brick Block was for many years the center of town.

In the 1940s, the post office moved from the Brick Block to the new brick building built for the First National Grocery Store just down the street from Post Office Square. The grocery occupied the western portion of the building that is now the Yellow Umbrella, and the post office was to the east. Note how the trees around the Methodist Church tower have been erased and the tower drawn in to add a recognizable feature to the scene. (Courtesy of Wayne Gould.)

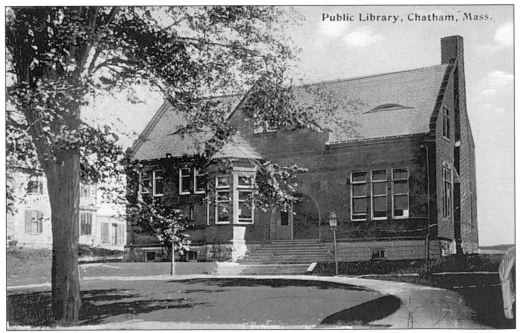

Public Library, Chatham, Mass.

Successful businessman and Chatham booster, Marcellus Eldredge, decided to establish a library in the center of town—a focus for his Chatham civic work. Hiring a student of Henry Hobson Richardson, Eldredge envisioned a stylish modern building of red brick with Romanesque detail and the crisp simplicity of the arts and crafts movement. The dedication of the new library took place on July 4, 1896, beginning with a parade from Eldredge's Watch Hill mansion, led by costumed marchers, school children, and a band. There were numerous speeches, all published in the local paper.

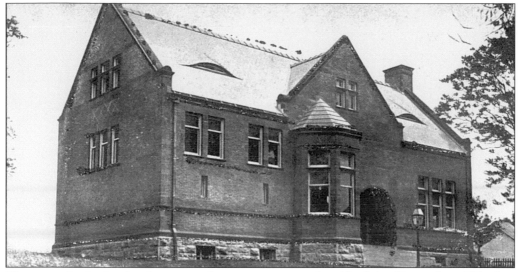

There was hesitation by the town selectman to accept the gift of the library from Eldredge, together with brother H. Fisher Eldredge's donation of 5,000 books. There was apparently a sentiment that Marcellus Eldredge's money, made initially off Cape from the sale of beer, was not appropriate for the staid Cape Cod town. Marcellus Eldredge was a skilled businessman, civic organizer and builder, in addition to being a shrewd politician. He had donated $5,000 to the Methodist Church across the street from his new library. Surely the source of Mr. Eldredge's money was secondary to his higher interests. The town accepted the donation.

In 1919, civic pride was high with the successful end of the First World War. George P. Rockwell purchased a French cannon to be displayed in a public setting to commemorate the war effort. The cannon was placed near the front door of the Eldredge Library. In the early 1950s, the cannon was removed from the library grounds and given to the VFW hall located in the old school building on School Street. It appears that the 650-pound cannon did not remain in place long, traveling about town, particularly on Halloween evenings. Eventually, it disappeared for good and is believed to be in the muck at the bottom of the nearby Mill Pond. The monument in the foreground is the Nickerson Monument, honoring the first settlers in Chatham.

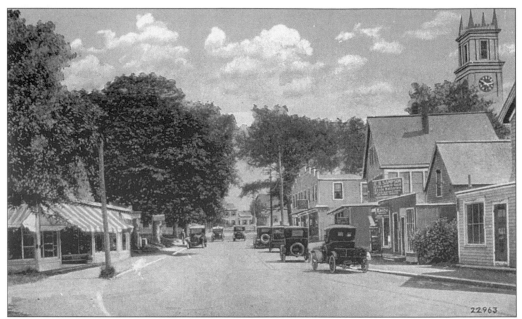

This view of Main Street looking east from Sears Park remains highly recognizable today. The building with the tiered roofline houses the Puritan Clothing Company. In the 1920s, Puritans occupied the left part of the building, shared with Richardson's, a dry goods store, and Coffin's, a drugstore. The building with the awning has had a series of uses, including the Gregorian Oriental Carpet Store in the 1930s and 1940s. (Courtesy of Wayne Gould.)

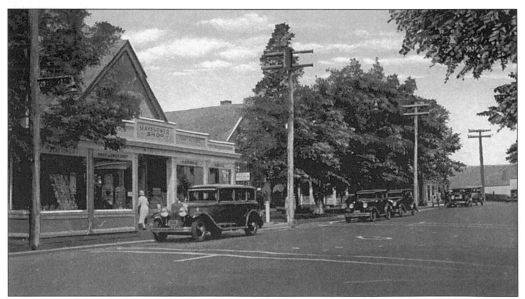

The Mayflower Shop, shown here in the 1930s in an early E.D. West card, like many businesses in the Chatham, began as a private home. The shop started in 1884. Since the turn of the century, it has been a frequent stop for both tourists and townspeople who buy newspapers, daily necessities, and, of course, postcards.

This view of the Mayflower Shop from the 1940s shows buildings that house the Candy Manor and Hearle Gallery on the right. The First National Store building is evident in the distance on the left. Again the tower of the Methodist Church is drawn in as a familiar feature, only this time the spikes of the tower are tied together making it look somewhat like the storm signal tower at the lighthouse.

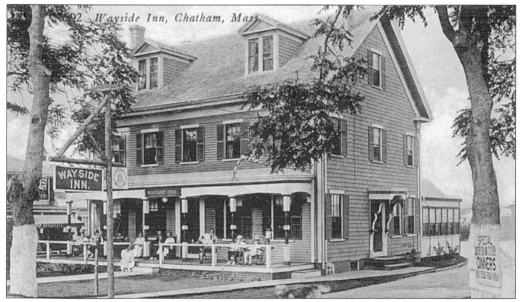

The Wayside Inn has long been the convenient place to stay in the heart of town. Starting as the Ocean House in 1860, the Wayside Inn was expanded with the need to accommodate increasing numbers of boarders. The long porch along Main Street was a popular setting from which to observe the busy activities of town. (Courtesy of Wayne Gould.)

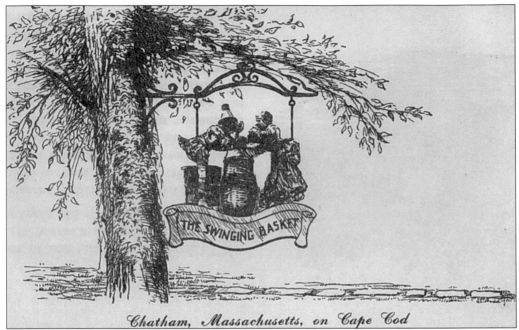

Chatham, Massachusetts, on Cape Cod

Most of the buildings on Main Street began as homes and were converted to stores or commercial buildings. The Swinging Basket was an elaborate complex of shops that included an expanded house and three outbuildings surrounding a courtyard and garden.

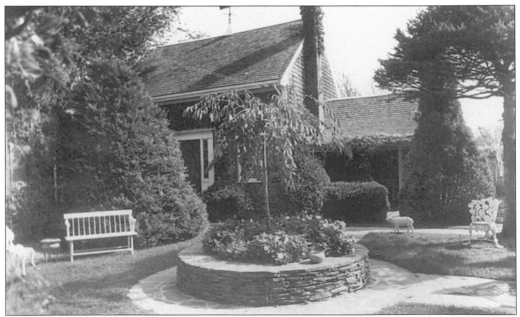

The garden at the Swinging Basket was carefully landscaped with numerous sculptures, lawn ornaments, and a wishing well. There is a series of over 20 postcards that document this garden. Today, the garden is still used as a courtyard for small shops and is an effective retreat off busy Main Street.

Five

MILL POND AND
OYSTER POND

Mill Pond has always rested quietly in the center of Chatham surrounded by the active life of town, the Old Village, and lighthouse to the east, Main Street to the north, and Stage Harbor to the south. Mill Pond defines Tom's Neck and has long been a favorite place for visitors. Protected from storms and connected through Mitchell River and Stage Harbor to Nantucket Sound, Mill Pond was a popular anchorage for shell fishermen and recreational boaters. From Mill Pond there were great views of the Old Mill, the lighthouse and other buildings in the Old Village, and buildings along Main Street.

Just off the western end of the commercial stretch of Main Street, Oyster Pond shared many of the appealing features of Mill Pond. A safe anchorage for small boats, the pond is connected to both Nantucket Sound and homes in the village.

By 1905, both Mill Pond and Oyster Pond were the focus of the developing second home industry and were popular swimming ponds. The rolling hills along their shores afforded numerous sites for summer homes to people who enjoyed cool summers along the coast.

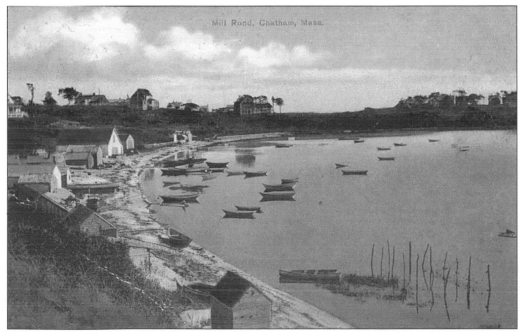

Mill Pond extends from the Mitchell River Bridge to the western edge of the Old Village. Little Mill Pond is the innermost part of this system and has easy access from the commercial part of Main Street. Between 1900 and 1940, the Mill Pond was a much more evident part of town than it is today, with fewer houses along its borders and few trees or shrubs to obscure the view.

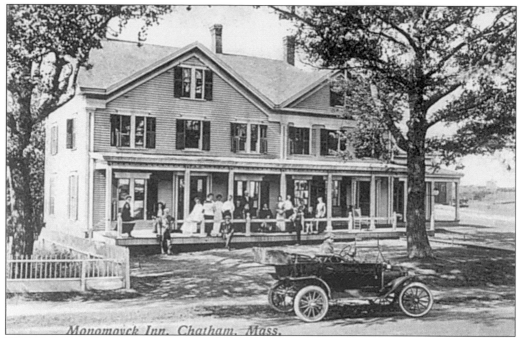

Monomoyck Inn, Chatham, Mass.

The Monomoyick Inn, now the Cranberry Inn, was the only hotel on Mill Pond. The name of the inn was changed from Monomoyick to Cranberry, presumably, because it was easier to remember and connected the inn to a Cape Cod and Chatham tradition. The Inn has been expanded several times and was for many years painted a cranberry red.

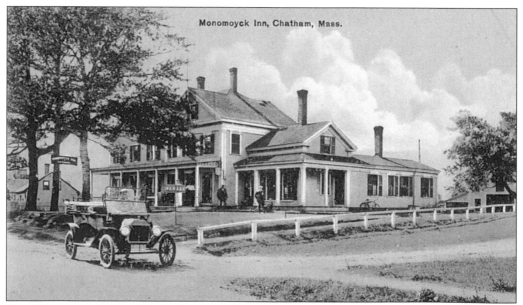

Monomoyck Inn, Chatham, Mass.

The Monomoyick Inn defines, for some, the western limit on Main Street of the Old Village. The Inn began as the Traveler's Home and is the oldest continuously used hotel in Chatham. The name Monomoyick referred to a local group of Indians of the Mattaquason tribe. Located on a salt marsh cove off the Mill Pond, the Monomoyick Inn looked across the water to the south. It was only a short walk for a warm swim in Little Mill Pond.

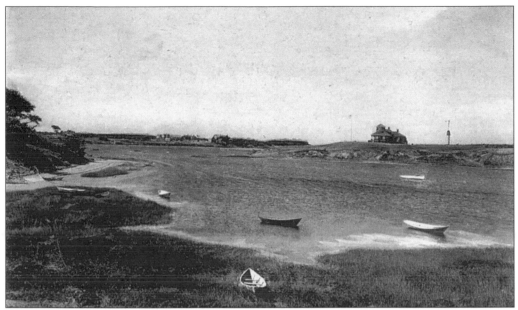

The cove immediately south of the inn was managed as a commercial cranberry bog up until the 1940s. Near this outlet from the bog, there was a dyke to prevent tidal flooding and to regulate the water level in the bog. Small, marginal bogs such as this one were not commercially viable and were eventually abandoned. The dyke is still evident today near the small wooden bridge that crosses the outlet stream. The bog vegetation has reverted to salt marsh.

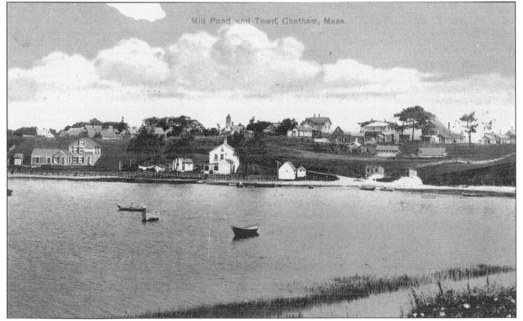

On the north side of Little Mill Pond, Mill Pond Lane and Homestead Lane lead from Main Street to the pond shore. Shown on the horizon are the backs of buildings located on Main Street. Recent farms bordering the pond were at this time being displaced by houses. The small tower to the right of center was a part of the Ziba Nickerson home on Main Street at Mill Pond Road. This building is now a jewelry store.

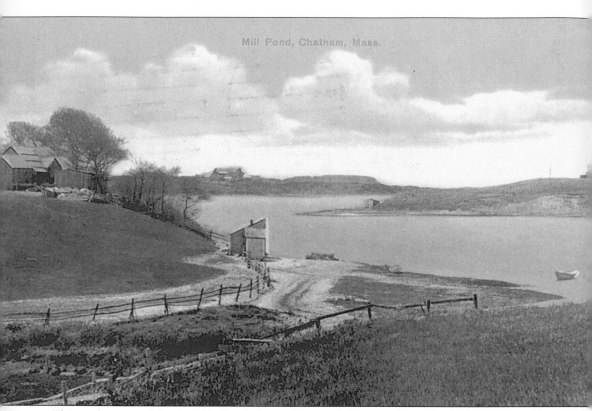

Mill Pond, Chatham, Mass.

This early view of Little Mill Pond shows the pond shore at the end of what is now Chase Street. The fences are along the outlet of the former cranberry bog behind the Cranberry Inn. There is a small footbridge across this stream today. There was easy access to the ponds and Stage Harbor from Main Street homes and businesses. The buildings to the left are remnants of a farm at the point where Chase Street and Sunset Lane are today. The large home to the right was owned by Tom Young. (Courtesy of Nancy Ryder Petrus.)

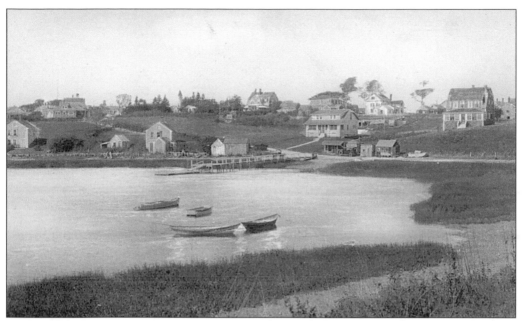

In the 1920s, a town pier was constructed along the north shore of Little Mill Pond. It was used to launch small boats, for fishing, and for a warm swim at high tide when it was safe for diving. The pier has been rebuilt many times and is a well-known feature at this town landing.

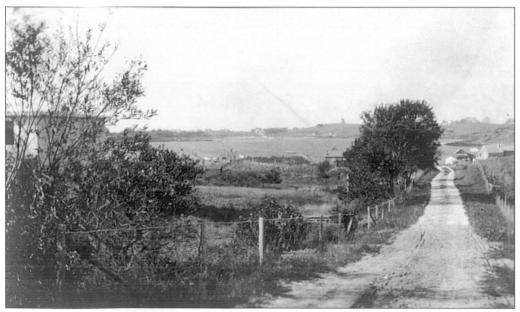

Connecting the Old Village to the Mill Pond are four short streets off School Street: Water Street, Chase Street, Sunset Street, and Eliphamets Lane. Eliphamets Lane, shown here in an early real photo card, was the most frequently used for access to fishing shacks, the Tom Gill boatyard, the bathhouse, and later to the Spaulding Dunbar boatyard and rental cottages.

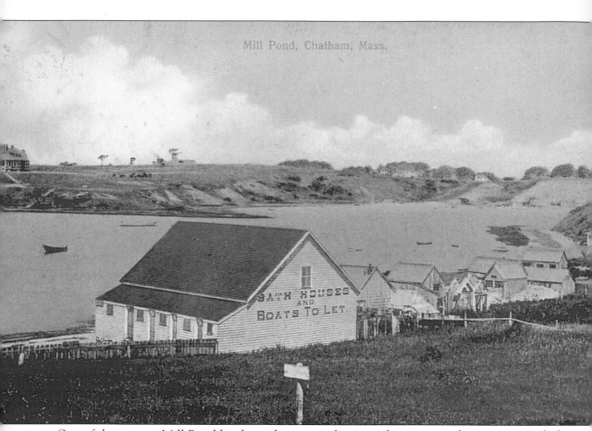

Mill Pond, Chatham, Mass.

One of the reasons Mill Pond has been documented in over thirty postcard scenes, particularly between 1910 and 1930, was the popularity of the bathhouse and boat rental facility. Many early tourists swam in the shallow waters of the Mill Pond and rowed around its quiet waters. Across the pond from the boathouse was an open area off Cross Street, referred to as Rink Park in 1912 when the town celebrated its 200th anniversary. The park was named after a popular roller skating rink that collapsed in an 1892 storm. (Courtesy of Wayne Gould.)

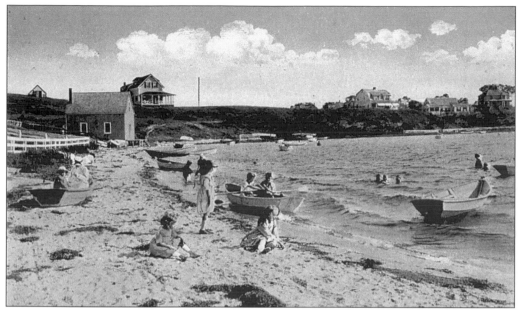

Mill Pond was a place for families. The water was shallow and calm and crowded with beach-goers in the summer. Many children in the Old Village and summer visitors have fond memories of their days along Mill Pond.

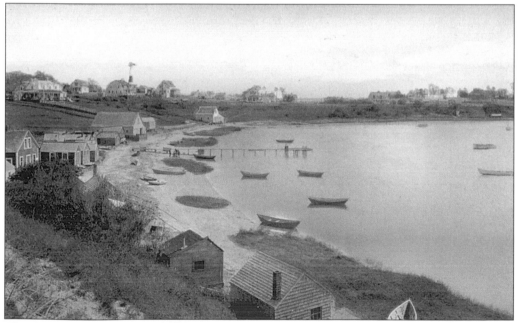

This Sawyer view of the east shore of Mill Pond, taken from the high ground at the end of Sunset Lane, shows the salt marsh along the pond border trampled by frequent travel from boathouses and fishing shanties to the water.

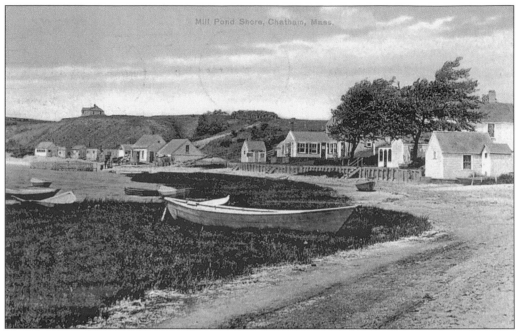

The shanties along the east shore of Mill Pond were frequently photographed and the subject of numerous postcards, such as this Dickerman card postmarked 1913. At that time, the shanties were actively used by fishermen. Frequently damaged in storms and quickly replaced, the modern descendants of these small structures are now seasonal rental cottages. (Courtesy of Wayne Gould.)

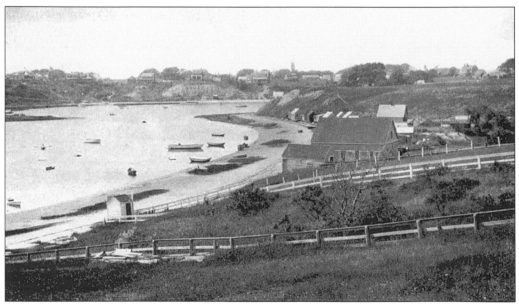

This early Sawyer postcard of the Mill Pond from the lawn of the Chase Cottage, "Porches," looks across Water Street toward the center of Chatham. The large building along the pond shore is the Mill Pond bathhouse. The Methodist Church steeple is visible along the town skyline.

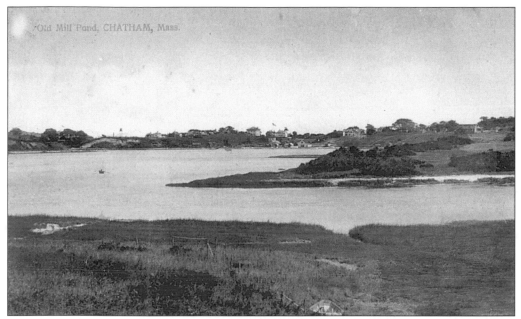

This postcard mailed in 1910 shows the view from the Old Mill across Mill Pond toward the fishing shanties along its eastern shore. The building near the center of the horizon is the Old Village School after which School Street was named. The school was built in 1858 and discontinued in 1924, served as a VFW lodge for many years, before becoming a private home.

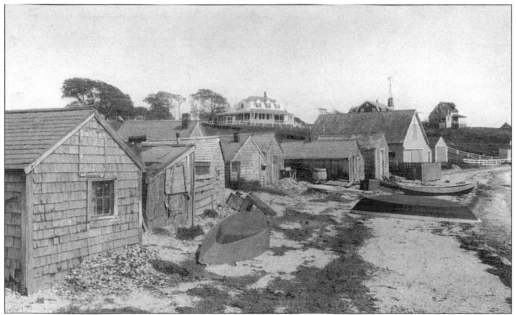

"Porches," the summer home of Avis Chase, is shown on the upper portion of this postcard. Avis Chase was born in the Old Village. She was the daughter of Mary Augusta Young, who ran a store at the corner of Water and School Streets. This house, with its broad porches, was the old store that was moved by Avis Chase to its current location closer to the pond. Mary Augusta Young was the model for the lead character in the popular Joseph C. Lincoln book, *Mary 'Gusta*, which was made into a Hollywood movie.

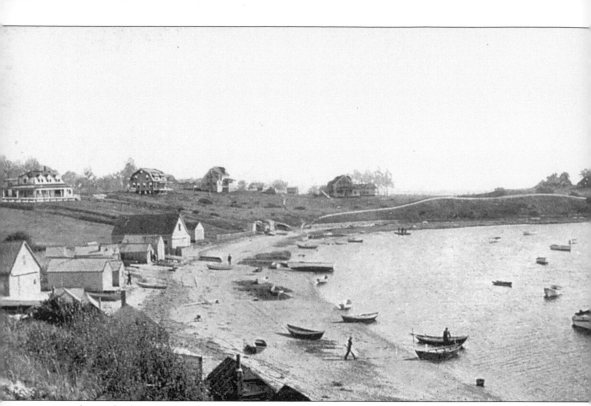

"Porches," the house with the broad veranda, is now part of a complex of three houses given by Avis Chase to the YWCA of Philadelphia for inner-city women to use in the summer. Avis Young married Silmon Chase, captain of a private yacht and a successful Philadelphia businessman. He died in his fifties and left Avis Chase a wealthy widow. Avis spent her summers in Chatham at her mother's home and when Avis died, she left her home and two additional houses to the YWCA, filling them with furniture from her Philadelphia home.

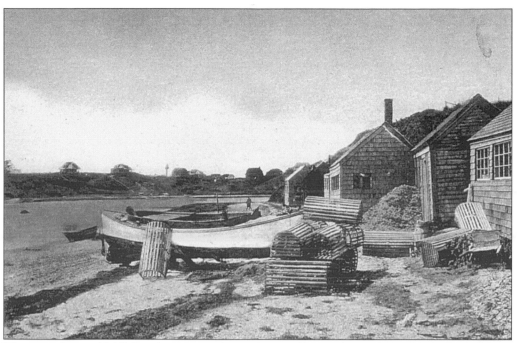

The east shore of Mill Pond was a working place well into the 20th century. These fishing shanties were owned by local families who either made their entire living from shellfishing and fishing or supplemented an otherwise limited income from work on the water. The local scenes of lobster pots and boats on the beach were a favorite topic of early postcards, especially those of Harold Sawyer.

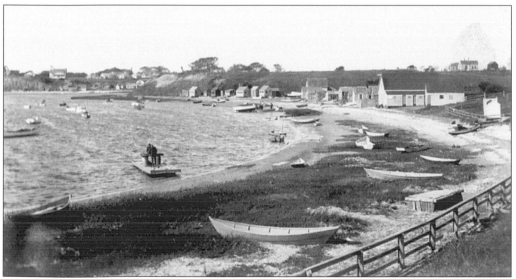

Mill Pond was an active part of the local fishing scene. In this real photo from the 1920s, the man on the raft is probably shucking quahogs that he has collected from the sandy bottom of the pond. Shell-fishermen still work the bottom of the pond using long rakes.

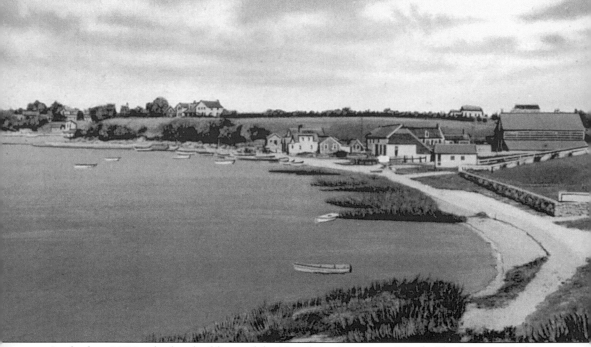

General View of Mill Pond, Chatham, Cape Cod, Mass.

In the late 1930s, the last buildings of the Naval Air Station in North Chatham on Nickerson Neck were sold. Spaulding Dunbar, a naval architect, purchased some surplus materials from the Naval Air Station and used them as part of his new boatyard at Mill Pond. Built in 1938, the boatyard is located off Eliphamets Lane on low-lying ground that had once been a small cranberry bog. The boatyard has recently been leased by Spaulding Dunbar's children to a new boat building and repair company that hopes to revive the boatyard tradition on Mill Pond.

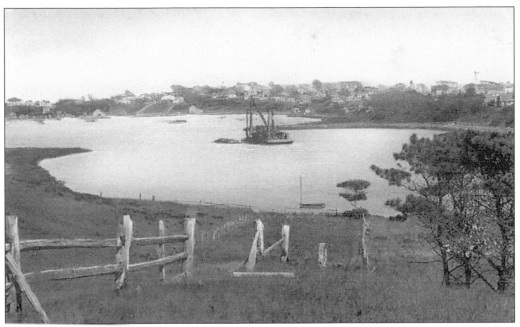

Boat repair at the Dunbar boatyard was active through the Second World War. Larger boats could enter Mill Pond from the drawbridge at the Mitchell River Bridge. It was necessary to periodically dredge a channel to the boatyard for these large boats. (Courtesy of Nancy Ryder Petrus.)

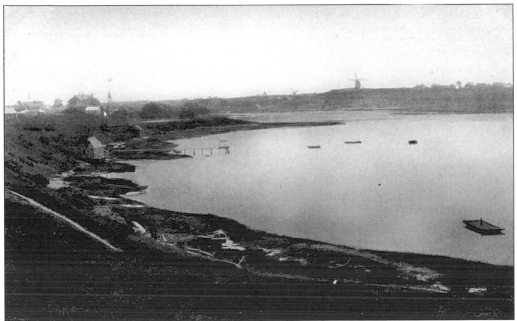

This Sawyer view of Mill Pond shows a seldom photographed section of the pond shore in the 1920s. Along the south side of the pond were private homes with docks and beach houses used only in the summer. The homes of J.S. Johnson, the Fleischmanns, and the Underwoods have shared this quiet shore of the Mill for several generations. The silhouette of the Old Mill appears on the horizon. (Courtesy of Nancy Ryder Petrus.)

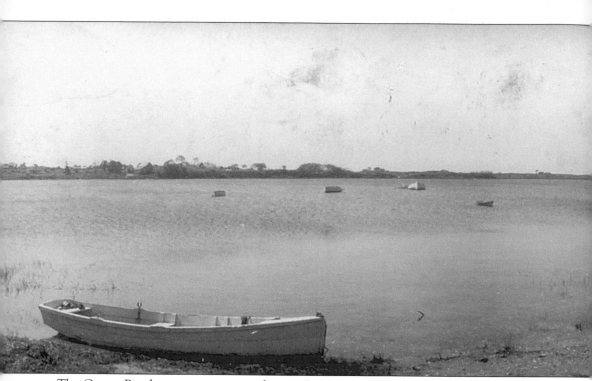

The Oyster Pond was a scenic part of town. In 1900, it was a landscape of farms and coastal features. Subsistence farming was still common in Chatham. Sections of Main Street, The Old Village, and the sites of new summer homes such as those along Oyster Pond were a combination of farms and homes of businessmen, seamen, and vacationers. The rural coastal

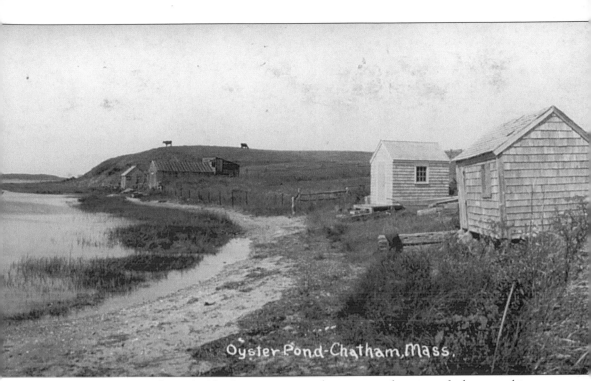

Oyster-Pond-Chatham, Mass.

character of Cape Cod, and Chatham in particular, was a favorite of those making postcards with numerous panoramic scenes as well as standard cards. (Courtesy of the Eldredge Public Library.)

West Chatham, Mass., View from Norold Hill.

This often produced Chatham card shows the mouth of the Oyster River where it enters Stage Harbor. Early in Chatham history, the sandbars and salt marsh borders of the Oyster River were a convenient site for boat access to Nantucket Sound and the productive waters of Oyster Pond.

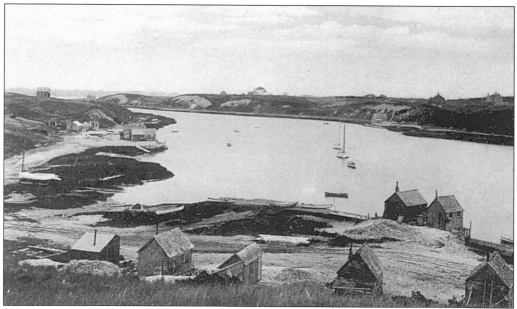

Like Mill Pond and the beaches along the North Chatham shore of Pleasant Bay, clusters of boathouses and fishing shanties lined the shores of the Oyster River. There were piles of shells, discarded equipment, and lobster pots scattered along the borders of the river among the many fishing shanties. From the early days of Chatham's European settlement, Oyster River was divided into deeded "King's Grants," which allowed individuals to receive exclusive rights to harvest shellfish from specific areas.

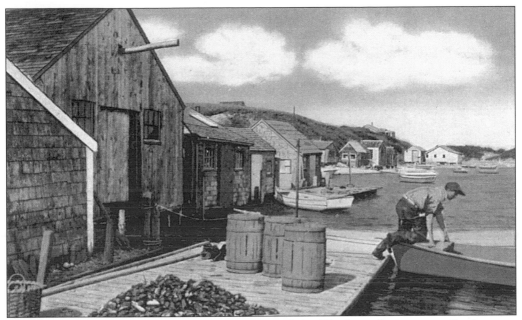

The Oyster River fish houses were an active part of the Chatham tourist scene. Seed oysters brought from Long Island were placed along strings in fixed beds and harvested in the fall. Scallops were not acknowledged as edible until the late 1800s, and were abundant near the Oyster River shanties. Oysters and scallops could be purchased directly from shell fisherman from the small wharves along the Oyster River.

The northeast corner of the Oyster Pond borders Stage Harbor Road nearest Main Street. This view looking down Pond Street to the head of the pond shows the location of the current public beach when it was still a salt marsh.

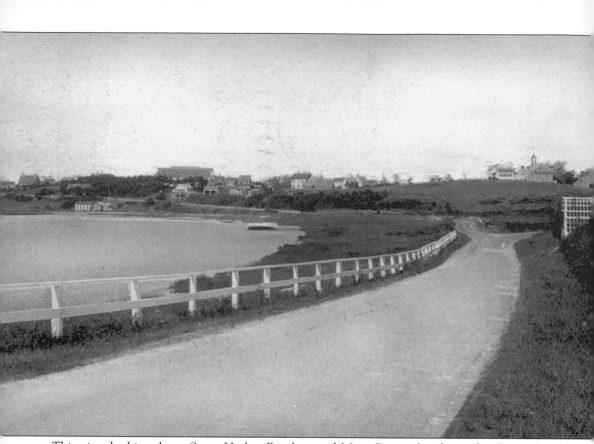

This view looking down Stage Harbor Road toward Main Street also shows the Oyster Pond Public Beach when it was salt marsh. The white arbor gate is one of the entrances of the Howes Estate, which overlooks the pond. The building with the cupola is the new school built in 1924, and the large building left of center on the horizon is the Chatham Manor. It was located off Main Street behind Manson Motors and served as a roller skating rink and recreational center often used by the nearby school.

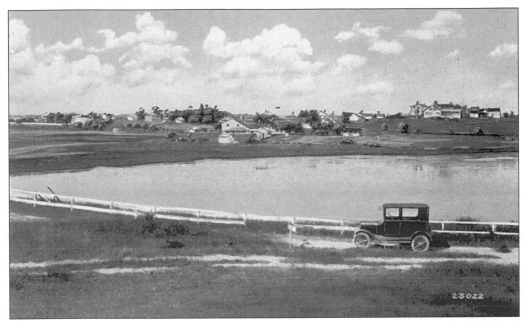

The Oyster Pond was a convenient location with easy access to town and the harbor, and had great views. Many elegant summer homes were built along its shore including the home of Louis Brandeis, Chief Justice of the U.S. Supreme Court. Justice Brandeis left funds to the town of Chatham for a scholarship to Brandeis University for a Chatham High School senior.

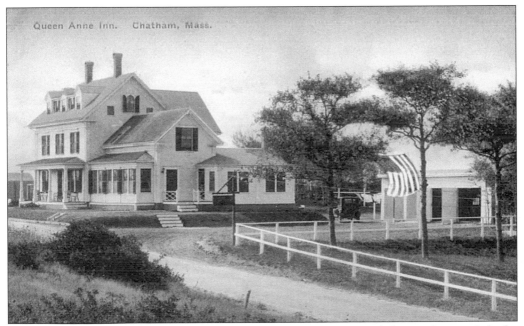

The Queen Anne Inn was originally a private home that was expanded several times. It had a view of the Oyster Pond before trees and houses obscured the horizon to the south. Well located in town, the inn was on the main road from Chatham to Harwich Center and was, in 1900, only a short walk to the commercial part of Main Street and the Oyster Pond.

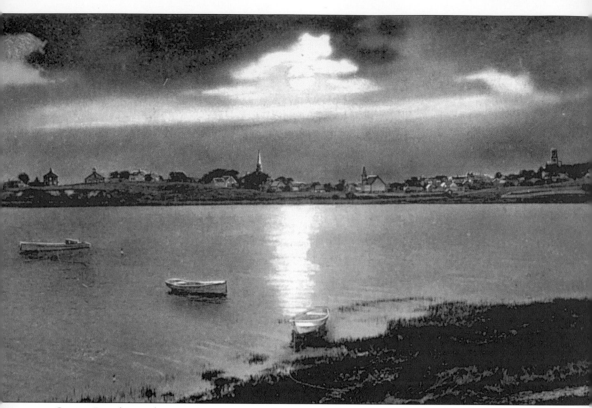

Oyster Pond is today a quiet spot near the center of very busy modern Chatham. Most of the margin of the pond today is privately owned. The pond is, however, highly visible to anyone passing by. Sunsets at the edge of the pond are often spectacular. This moonlight scene shows the town skyline with the Congregational, Universalist, and Methodist Churches. (Courtesy of Wayne Gould.)

Six
CHATHAM BARS INN
AND THE BOULEVARD

Since it was first built in 1914, Chatham Bars Inn, known as "CBI," has been the leading hotel in Chatham, setting the tone in town for affluent tourism. Located across from the inlet into Old Harbor, CBI was built as a large, full service hotel with a nine-hole golf course and numerous "cottages" designed to look like seashore mansions. CBI is situated a mile north of Chatham Light on the Boulevard, which is now called Shore Road, with commanding views of Old Harbor and North Beach. Nearby was the Hawthorne Inn, another wooden cottage-style hotel. Nearer the Old Village just off Main Street was the Mattaquason Hotel. All three of these hotels catered to families who, in the early part of the 20th century, would stay at the seashore for several weeks or even for the entire summer. Near the mid-point of the Boulevard was "Crosstrees," summer home of Joseph C. Lincoln from 1916 until his death in 1944. Joseph C. Lincoln wrote nearly 50 books of fiction and poetry with Cape Cod themes, developed from his experiences and stories he had heard in Chatham.

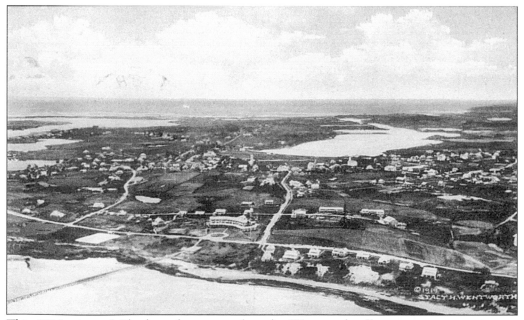

This 1919 view of Chatham from a seaplane by Wentworth offers a great perspective on Chatham Bars Inn and its surroundings. CBI is the arching building in the lower center of the view with its circular front drive. It is strategically located by the quiet waters of Old Harbor, only a short walk from Main Street. Beyond Main Street is Oyster Pond with Nantucket Sound in the distance. Visitors to the inn generally arrived in town by way of the railroad whose main station is just right of center, only a short ride from the inn.

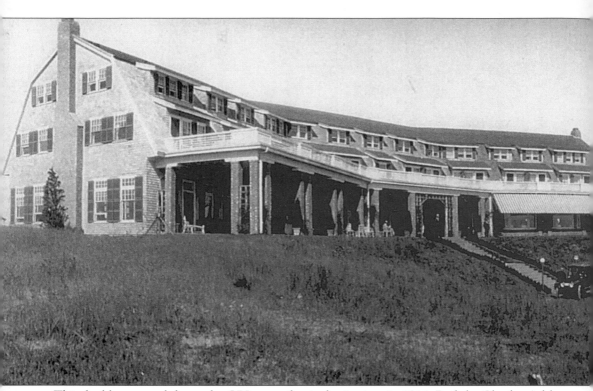

This double postcard shows the CBI soon after its beginnings in 1914. Built by Charles Ashley Hardy of Boston, the inn was constructed as an elegant addition to the tourist industry in Chatham. Constructed only 20 years after the closure of the equally elegant Hotel Chatham, Chatham Bars Inn was also large, but in a better location. It was designed to be a self-contained

tourist destination. This view shows CBI and the cluster of shingled cottages that were a part of the complex. The layout and structures are highly recognizable today, with the exception of the landscaping which appears here to be little more than a few trees recently planted in old pasture. (Courtesy of the Eldredge Public Library.)

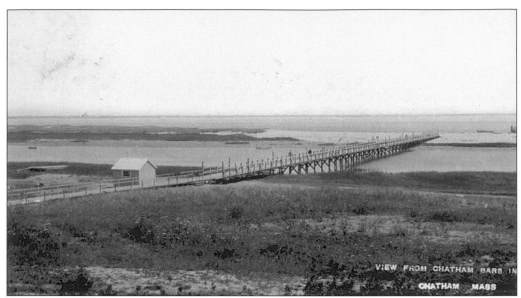

VIEW FROM CHATHAM BARS IN
CHATHAM MASS

Chatham Bars Inn was built on the mainland immediately west of the inlet into Old Harbor. It was only a short sail from the inn to the open ocean. Many of the early visitors chose Chatham because of its reputation as a good location for hunting and fishing. In front of CBI was a large sandbar that moved around over time. A long pier was built soon after the inn was constructed to carry bathers to both calm, shallow water on the inside of the bar and colder, deeper water on the outside.

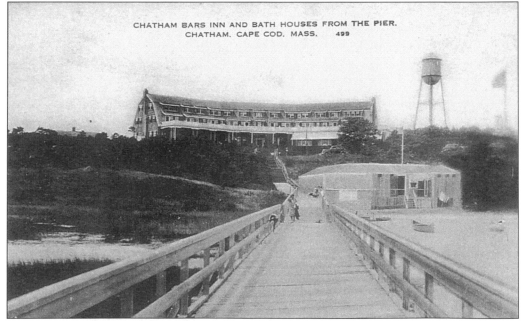

CHATHAM BARS INN AND BATH HOUSES FROM THE PIER.
CHATHAM, CAPE COD, MASS. 499

There are literally dozens of postcard views of CBI from the water. The building to the right of the pier is the bathhouse built in the early 1920s. A water tower was essential to store the vast quantities of water that it took to run the inn before water was pumped from a municipal source. Because there is little topography to create water pressure, a tower served both for storage and pressure. Other views of CBI show an earlier tower behind the inn with an attached windmill.

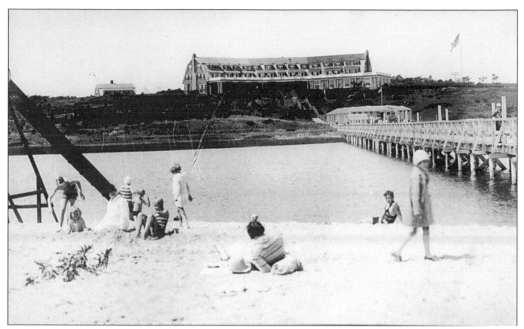

CBI was a family place. Many large families came to Chatham for long summer stays. The mother, children, maids, and nannies stayed at the inn with the father making occasional weekend visits from the city. Some families were annual visitors and became deeply connected to the town, eventually buying property and building summer homes.

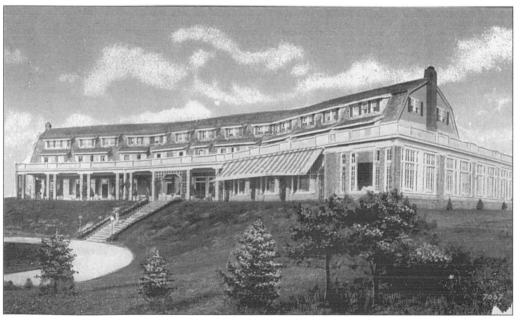

This commonly seen view of CBI features the large dining room that was expanded soon after the initial building was constructed. The minimal landscaping suggests use of locally available plant material, including pitch pines that were found throughout the area growing in dry, well-drained soil. The windmill and water tower have been eliminated from this view.

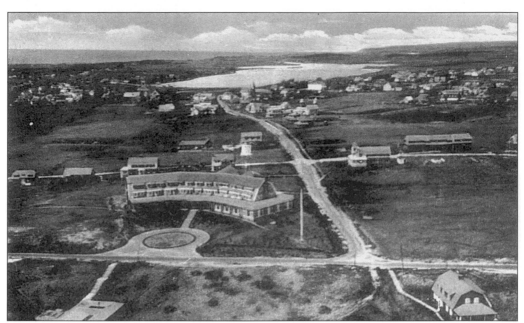

This view of CBI by Wentworth, taken in 1919, is labeled "from the blimp." It shows the open area around the inn that was used as a nine-hole golf course. Note that there are very few houses on Highland Avenue and the recently built Holy Redeemer Catholic Church is in the upper right. (Courtesy of Wayne Gould.)

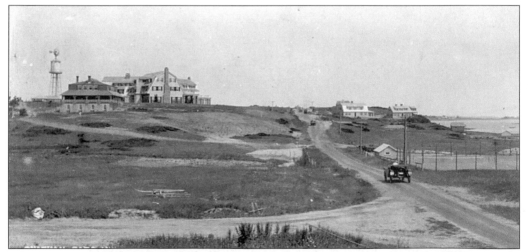

This postcard shows the intersection of Chatham Bars Avenue and Shore Road south of CBI before any houses had been built. The road is unpaved and sandy. Seaward of the Inn is a small building on the beach that housed a pump that brought salt water up to the inn. CBI proudly advertised both fresh and saltwater showers. Water was pumped to the inn and stored in the roof for showers. (Courtesy of Nancy Ryder Petrus.)

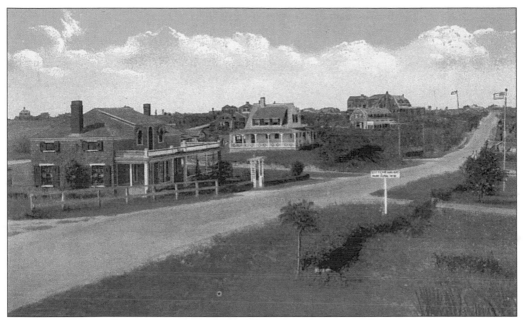

This view looking down Shore Road from near its intersection with Bay Road shows the new summer cottages that were appearing near CBI. Built like farmhouses or oversized cottages, these large, comfortable buildings were generally only used in the summer and were often built by people who had first come to Chatham and stayed at Chatham Bars Inn. (Courtesy of Nancy Ryder Petrus.)

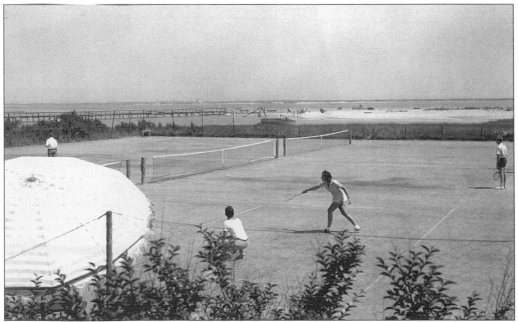

Chatham Bars Inn was a full service hotel, complete with tennis courts. These courts were located on the northeast corner of Shore Road and Chatham Bars Avenue. They were virtually on the beach with cool breezes in the summer, often a real wind, and, of course, great views of Old Harbor. Old Harbor Station is faintly visible on the horizon.

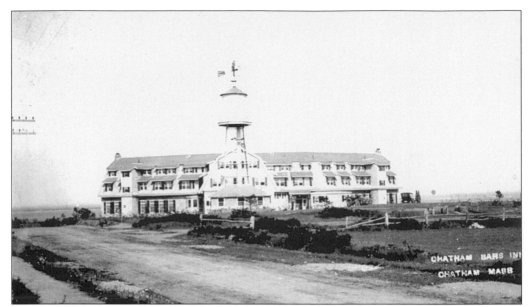

This unusual view of CBI from Seaview Street highlights the back of the building and the water tower topped by a windmill. The hill along Seaview Street was called Wicket Hill, named for the croquet games played there. There are tourist tales of "mooncussers"—people on Seaview Street who walked horses with swinging lanterns around their necks to make seamen believe that they were seeing boats at anchor in a harbor. This might have led some boats to run aground along the bars off Chatham and create a salvage opportunity.

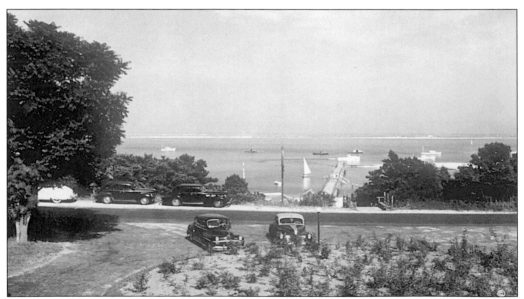

The view from the front porch of CBI in the 1930s shows the signature rose garden in the circle and the pier with the ever changing sandbar. The inlet opening into Old Harbor had moved south and the sandbars in front of the inn changed. Now there are boats at the end of the pier in deeper water. The pier is barely needed for access to swimming. Beach use probably shifted to the area south of the inn in front of the tennis courts.

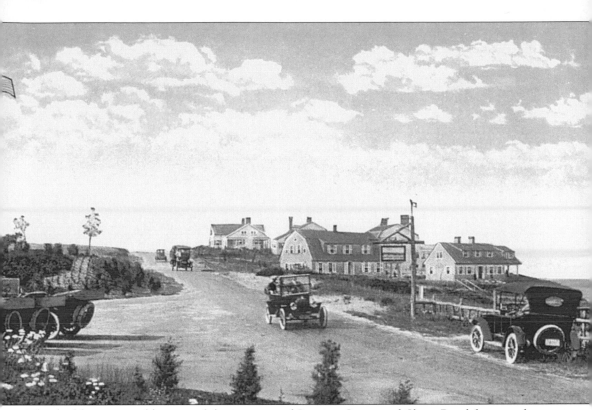

This highly recognizable view of the junction of Seaview Street and Shore Road features the cluster of cottages that were, and still are, a part of Chatham Bars Inn complex. There was a conscious effort on the part of developers to create an upper class tourist destination at Chatham with dignified buildings. These large structures, which were built as rental units, effectively established the trend for local development and for much of the town. Chatham did not see the widespread proliferation of small summer cottages that were characteristic of some other Cape Cod towns.

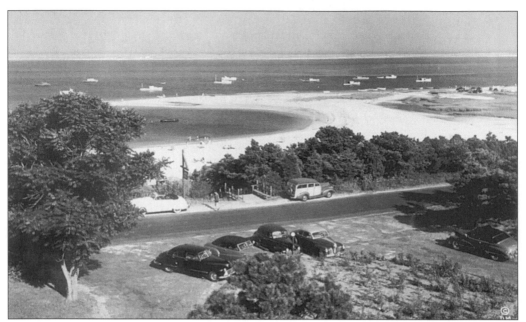

In the 1940s, the inlet into Old Harbor continued to move southward, changing the character of the inner harbor. Most of these boats in front of CBI are part of the Chatham fishing fleet moored in deeper, but calmer water. The small cove facing the inn created a calm place for children to swim with deeper, colder water nearby.

The front porch of CBI was a favorite place to meet for conversation or to read quietly through the afternoon. With spectacular views of the water and cool breezes, the porch was a typical and important feature of large seaside hotels.

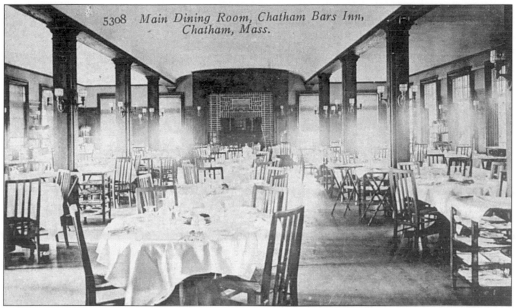

5308 *Main Dining Room, Chatham Bars Inn, Chatham, Mass.*

The dining room at CBI was fancy and formal. Families dressed for long, multi-coursed dinners. The inn hired the best chefs and used local help in the restaurant. They also hired college students and housed them in a dormitory that was on the golf course margin.

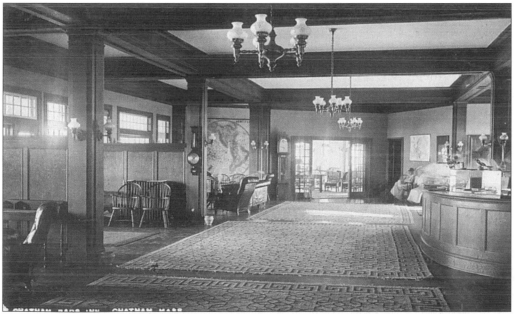

CBI also had a tastefully lavish lobby filled with oak paneling, comfortable chairs, and a map of the world. The main space was divided into small alcoves where intimate conversations could be held with reduced drafts. There was also a living room at the south end of the building with a fireplace. All are still present today.

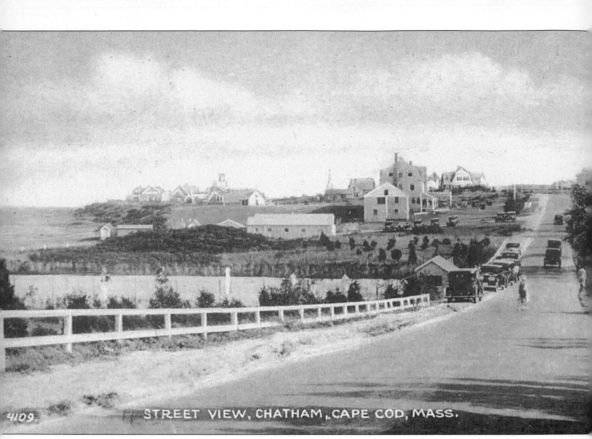

STREET VIEW, CHATHAM, CAPE COD, MASS.

This 1930s view from the front of Chatham Bars Inn looks south down the Boulevard, later called Shore Road. The cars are parked in front of the tennis courts. The large three-story building is the nearby Hawthorne Inn, and the last building visible on Shore Road in the distance is "Crosstrees," the summer home of Joseph C. Lincoln. This same postcard was also produced with all of the cars and the two pedestrians removed. (Courtesy of Donna Lumpkin.)

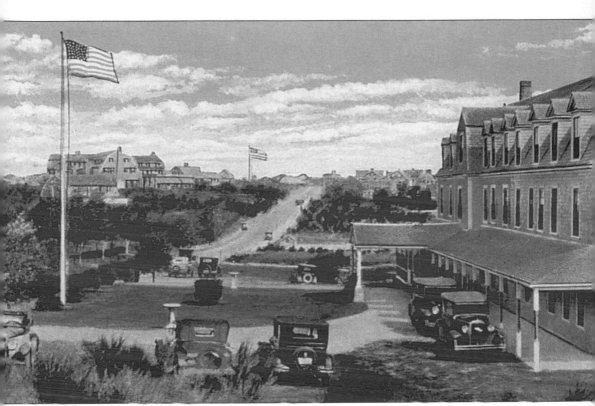

This view from the late 1920s is from approximately the front yard of the Joseph C. Lincoln home looking north down Shore Road to Chatham Bars Inn. Although smaller and far less formal than Chatham Bars Inn, the Hawthorne Inn, shown to the right, was also a popular hotel. The tennis courts and cottages at CBI are visible beyond the Hawthorne. The flag shown seaward of Chatham Bars Inn is sketched in and would be huge if it were actually that big from this distance.

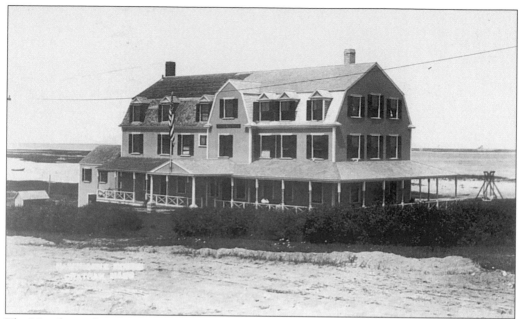

The Hawthorne Inn was started by Grandy Boyd as a casual boarding house in a building on the beach below the Chatham Lights. She was so successful that she decided to convert her great-grandfather's house on Shore Road into a small inn with a dining room.

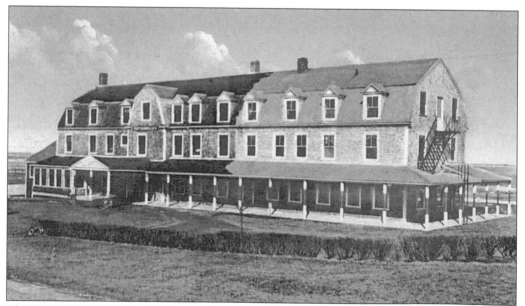

The Hawthorne Inn was expanded and took on the look of other shingle-style hotels in Chatham. Three stories high with a broad porch, the inn was now called The Hawthorne Inn after a hawthorne hedge planted along the Boulevard. It was a less expensive alternative to Chatham Bars Inn and the Mattaquason, both not far away. The Hawthorne Inn was occupied by the military in the Second World War, torn down in 1959, and replaced by a modern motel.

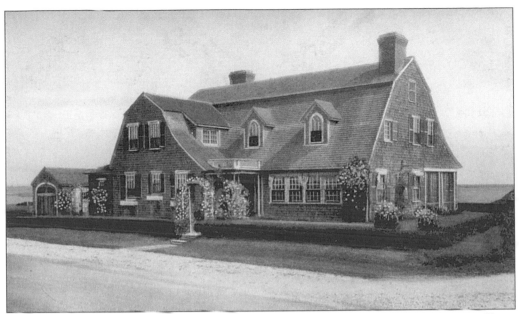

"Crosstrees" is a short distance south of Chatham Bars Inn with a prominent position on Shore Road. This house was built by Joseph C. Lincoln in 1916 as a summer home. He was a very successful writer who lived most of the year in Princeton, New Jersey. His weathervane, not shown in this view, was a writer's quill. Today this home is privately owned with a dolphin weathervane.

The view from Joseph C. Lincoln's "Crosstrees" was often photographed and became a signature scene of old Cape Cod with its sand road, windmill, near water view, and distant barrier beach. The windmill was never functional as a mill but was a guesthouse of the neighbor and used only in the summer. These windmills were constructed at many summer homes in an attempt to create an old seaside New England landscape.

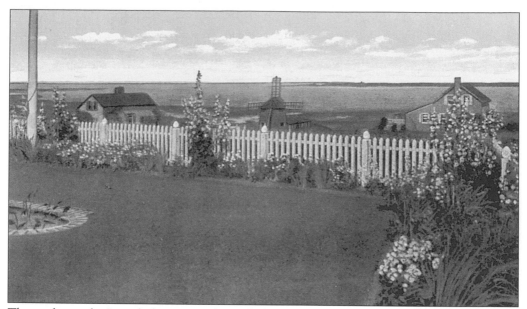

The garden at the Lincoln home was also well photographed and became a symbol of quaint life by the sea with a white picket fence and mass of color including the characteristic Cape hollyhocks and rambler roses. The living room at "Crosstrees" looked across this garden. Lincoln frequently spoke with visitors from this setting when he was not secluded in his massive writing effort. Over a period of 47 years, he reliably produced approximately one book per year.

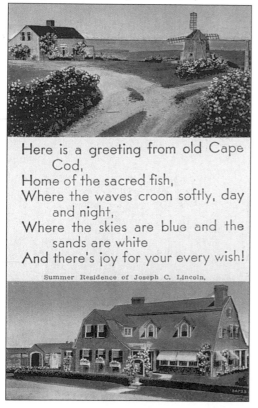

Here is a greeting from old Cape
 Cod,
Home of the sacred fish,
Where the waves croon softly, day
 and night,
Where the skies are blue and the
 sands are white
And there's joy for your every wish!

Summer Residence of Joseph C. Lincoln.

From the late 1920s into the 1940s, postcards with Cape Cod scenes and poetry were produced to capture the tranquil feeling of being by the sea in the idyllic Chatham setting. This picture of "Crosstrees" and its view are as much a part of Chatham and Shore Road now, as they were over 60 years ago.

Seven

PLEASANT BAY, OLD HARBOR, AND THE CHANGING SEA

The major harbor along the east coast of Cape Cod is Old Harbor leading into Pleasant Bay. First called, Monomoyick Bay, this large bay is defined by the changing barrier beaches that front Orleans and Chatham along the Atlantic.

In the 1850s, the entrance to Pleasant Bay was across from Scatteree Point. By 1914, the inlet had extended southward to east of CBI and by 1928, it was east of the lighthouse. The location of the inlet, over time, has defined the uses of the Old Harbor and Pleasant Bay.

In the 19th century, salt works lined the shores of Chatham, particularly around Chathamport. There was a shipyard, located on Nickerson Neck, followed by the Chatham Hotel, the Eastward Ho! Golf Course, and in World War II, the Naval Air Station. Nearby, the Chatham Marconi Station, designed to provide wireless service to Europe, was built in 1913–14

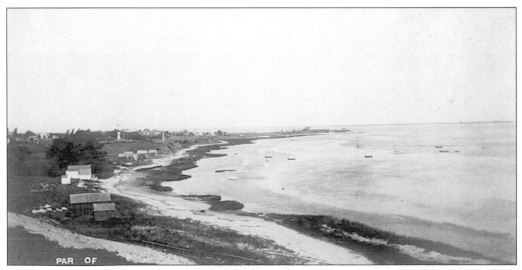

This view of Minister's Point looking north shows the main portion of the Old Harbor, which up until the mid-19th century was the main harbor in Chatham. At one time, salt drying "stages" lined these shores. Located just west of the inlet into the harbor through much of the 19th century, the Old Harbor had easy access to the Atlantic shipping route and open ocean fishing.

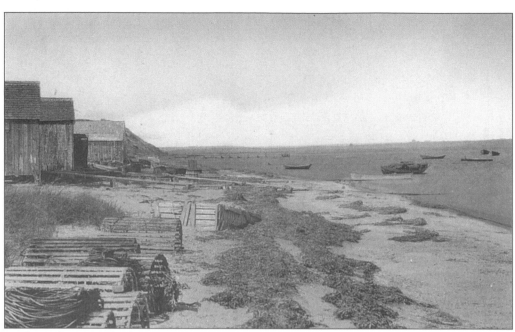

By the early 1900s, the beaches around Minister's Point and Scatteree were no longer the active site of shipping and fishing. Salt making from drying seawater was replaced by mining salt from underground deposits far from the coast. The shores of the Old Harbor were still, however, used by local fishermen who maintained small photogenic shanties to store small boats, nets, and other fishing gear. These buildings, lobster pots, and boats were favorite subjects of postcards by Harold Sawyer in the late 1920s.

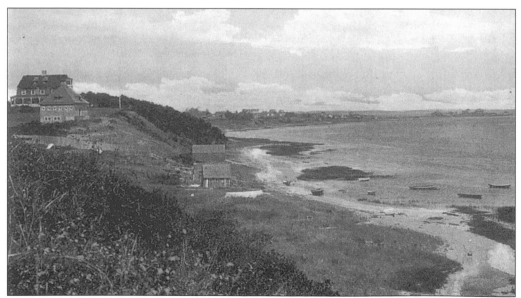

In the 1920s, Aunt Lydia's Cove was a small town landing just north of Chatham Bars Inn. Protected by Tern Island and other sandbars inside Old Harbor, the cove was a very sheltered anchorage for small boats and convenient to the inlet. John Paine, a Hollywood actor, owned the large shingle house overlooking the Cove at one time.

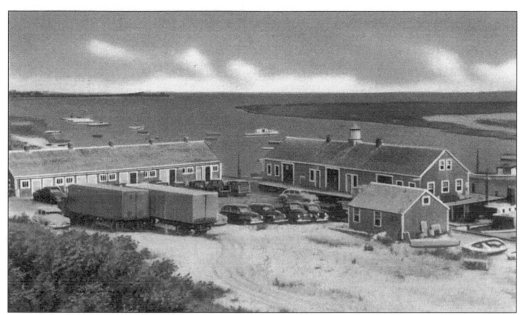

Soon after the Second World War, Chatham began to focus on building town infrastructure. The inlet into the harbor was located south of Chatham Light and sand deposits near Aunt Lydia's Cove were more stable, allowing for the development of a small efficient harbor. The town built the Fish Pier in 1946. Town Selectman, Willard Nickerson, then built his fish market on town-owned land. It had to be moved off town property.

The Fish Pier was a modern facility in the late 1940s, with moorings for numerous mid-sized boats, docks to offload catch, fish sorting and packing rooms, a parking lot for trucks, and a boat repair shop. In only a few years, an observation deck and an enlarged parking lot were built to accommodate the significant increase in tourism.

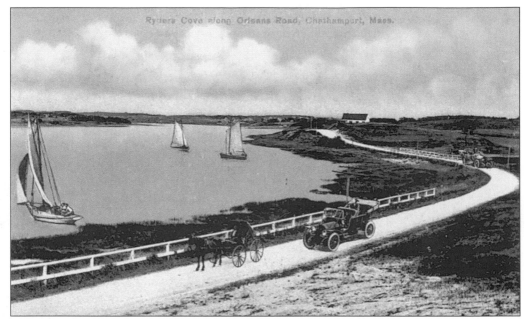

Ryder's Cove is another highly sheltered anchorage in Chatham. Defined and protected by Nickerson Neck within Pleasant Bay, Ryder's Cove was an important harbor for small fishing boats and today is popular for recreational boating. Visible from the main road between Chatham and Orleans, Ryder's Cove is especially scenic and has been the subject of numerous modern postcards, but few older cards. (Courtesy of Wayne Gould.)

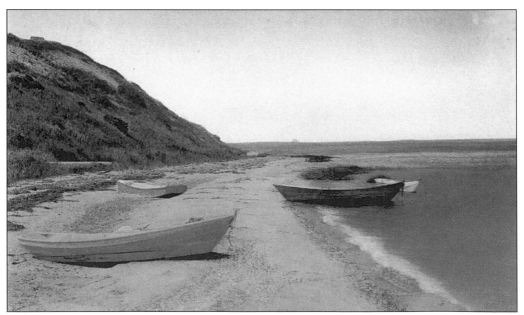

The shores of Chathamport were a favorite subject of Harold Sawyer. Sawyer's father had worked for Wallace Nutting, the famous early 20th century photographer. Sawyer produced dozens of hand-colored images of old Chatham using soft pastels, often with the yellows and pinks of dawn light.

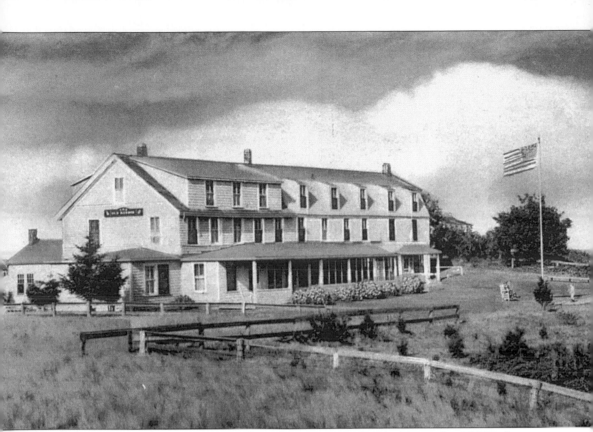

The Old Harbor Inn began in 1898 and was located near what had been the Old Harbor in North Chatham. Just a short distance from the water with great views of the harbor and North Beach, the inn was first a rooming house, "The Hattie Baxter House," located near the road in front of its current location. It expanded to a three-story hotel with porches and tourist amenities. The inn was a quiet retreat removed from town and the tourist district along Shore Road. It closed in 1956 and became a large private home.

MARCONI WIRELESS STATION CHATHAM M

The original Marconi "wireless" station was located in South Wellfleet where the headquarters of the Cape Cod National Seashore is today. In 1913, a new Marconi Station was constructed in Chatham at Ryder's Cove with several brick buildings including a small hotel. With a series of six 400-foot towers stretching from Ryder's Cove to South Chatham, this station was designed to transmit messages to Potsdam, Germany. World War I began soon after the station was built. The function of the new station was quickly revised to meet wartime needs.

During World War I, the Chatham Marconi Station was used by the military and played an important role in ship-to-shore communications. Connected with the nearby operation of the Naval Air Station at Nickerson Neck, the Chatham Marconi Station was an active part of coastal defenses. Run by RCA after the war, the station remained a significant part of coastal communications until the 1960s. The Chatham Marconi Station picked up the first messages from the sinking *Andrea Doria*. The station was later acquired from RCA by MCI in a large-scale transfer of assets. No longer needed by MCI, the Chathamport property with its brick buildings and land in South Chatham was sold to the town of Chatham in 1999.

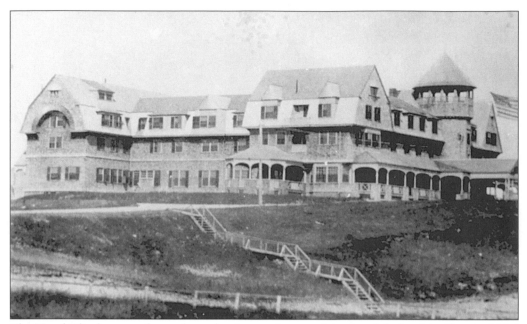

The Hotel Chatham was located on what is now the tee of the fourth hole of the Eastward Ho! Country Club. The site was certainly one of the prime spots in town, and would easily support any tourist-based business today with convenient highway access. Constructed by brothers H. Fisher and Marcellus Eldredge and partner Eben Jordan of Jordan Marsh in Boston, the hotel was built as soon as train travel was securely available in town. (Courtesy of Donna Lumpkin.)

The Hotel Chatham was a good idea, but a little too inaccessible at this site. The hotel was designed for upper-class tourism with all the latest conveniences. The first few seasons were highly successful and the business was full of hope. But the bumpy ride from the West Chatham train stop to the Hotel Chatham and a short national recession turned the good idea into a financial failure. After only four years, the hotel was closed and never reopened. It was partially torn down in 1907 and most traces of the complex were completely gone by 1915. (Courtesy of Donna Lumpkin.)

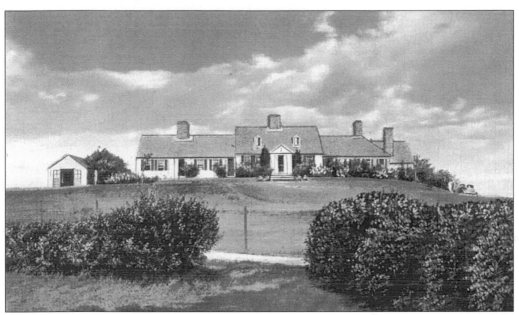

The Eastward Ho! Golf Club was incorporated in 1917 and work began on a professionally designed golf course with private membership. Shares were sold and construction continued slowly for several years with the spectacular new course opening in 1922. The Eastward Ho! clubhouse was constructed from three separate old buildings. The central section was built around 1800 by Ensign Nickerson who had a successful boatyard on Nickerson Neck. The two wings were from off-Cape.

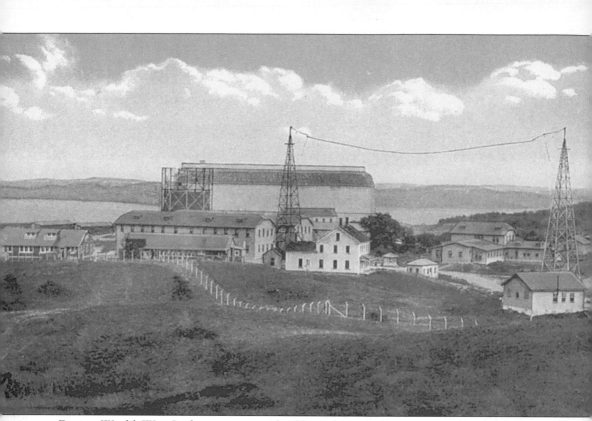

During World War I, there was considerable and justifiable concern about German naval activities off the coast of Cape Cod. Chatham was strategically located to serve as a watch point for the southeast portion of the Cape. The lifesaving stations and the Chatham Marconi Station were staffed with military. Chatham Naval Air Station was constructed at the end of Nickerson Neck. Flat with a clear approach over Pleasant Bay; the air station was a critical part of our coastal defense. Today, over 80 years later, it is hard to envision the focus on Chatham as a military base and possible point of foreign invasion. Between 1914 and 1917, however, the shores of town were the regular scene of military action. The base was disassembled in the late 1930s and later sold as surplus land picked up by residential development. (Courtesy of Donna Lumpkin.)

Not far off Pleasant Bay was the Acme Laundry, a major Chatham business for over 60 years. The laundry was located on the west side of Route 28 just north of Liberty Commons. Many Chatham teenagers looking for summer work began their careers at the hot and humid laundry. Serving all the major local hotels, the laundry was a highly successful enterprise. The stately Hydrangea Walk Mansion on Shore Road was built by Acme Laundry owner L.V. Eldredge. The laundry operation became antiquated by the 1970s and was torn down in the early 1990s.

The drive between Chatham and Orleans is one of the most picturesque on Cape Cod with periodic views of Pleasant Bay. At the Wading Place, a small tidal creek, Muddy River, enters Pleasant Bay. The main route to Orleans crossed this creek which was often flooded at high tide, hence the name Wading Place. A bridge was built over the creek in 1825. It was later changed to a culvert. Today, it is barely noticeable that a creek flows under the road.

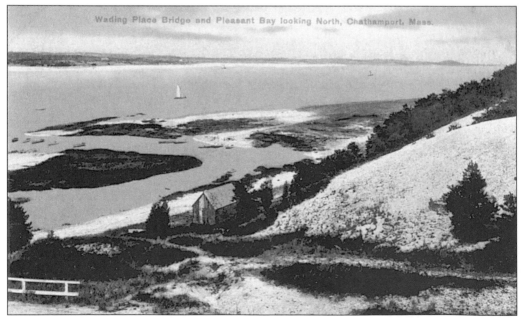

The Wading Place offers a scenic view of Pleasant Bay and shallow warm water. It is a calm children's beach with easy access off Route 28 and a fascinating, fast moving current that changes direction with the tide along Muddy River, now known as Monomoy Creek. The Wading Place was the subject of several Harold Sawyer postcards.

Eight
THE LIVING HERITAGE

Throughout the 20th century, Chatham has been aware of the value of its historic structures. Development in town has often merged old with new, combining New England practicality of reusing old buildings in an area with few large trees, with the desire to maintain the aesthetic values of the town. The old Atwood House was long an attraction in Chatham before its acquisition as the centerpiece of the Chatham Historical Society. The Old Mill was a fixture in the earliest postcard views of Chatham despite its long obsolescence. It was donated to the Town of Chatham and moved to its current location in 1954.

Old structures in town, including The Chatham Lighthouse, historic hotels, and houses, number in the hundreds and create a uniform and dignified backdrop for the modern town. Increased efforts to preserve the character and substance of Chatham have met with the usual conflicts with modernization, but have successfully resulted in a functional and vibrant town with the rich character of its past seen throughout the village.

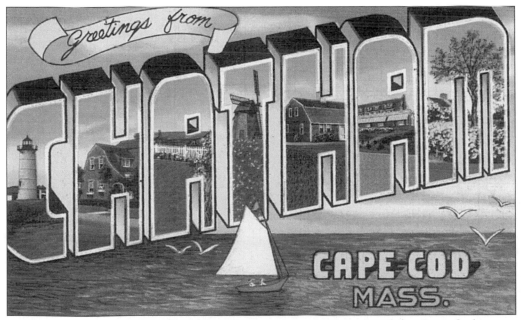

By the late 1930s and into the 1940s, Chatham was a major part of the Cape Cod tourist industry. The images of scenic Cape Cod are reflected in this large-letter card—the Chatham Light, the Old Mill, Chatham Bars Inn, Joseph C. Lincoln's house and view, and Main Street were fixed in the image of seaside Chatham.

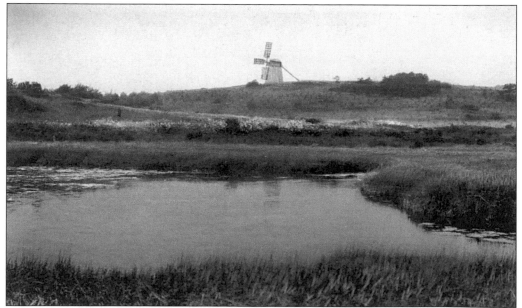

*Swamscott House,
Chatham —
Had a fine
day - good
sea breeze.
+ nice + cool
this evening
C K R.
Wed. Aug 17/04*

Arthur Livingston, Publisher, New York. 657

OLD MILL, CHATHAM, MASS.

The Chatham Old Mill was one of six mills in town in the 1800s. It is the only remaining mill structure from this period. Built in 1797, the mill was a gristmill used to grind corn into meal that could be stored dry into the winter. It originally overlooked the Mill Pond and the Mitchell River Bridge, and was a fixture in the postcard images of the harbor between 1904 and the early 1950s. All of the early Old Mill postcards are from this location.

Active use of the mill ended in the late 1800s. Realizing the historical significance of his structure, Stuart Crocker, who acquired it in 1939, gave it to the town. It was moved at town expense from its original location in 1954 to Chase Park, which was given to Chatham by Avis Chase to commemorate the life and work of her husband, Silmon Chase. Chase Park and the windmill are visible from the Chase Cottages off Water Street in the Old Village.

The Old Mill is a wind-driven gristmill that can be fitted with sailcloth to increase the transfer of energy from the wind to the spinning shaft that turns a grinding wheel. Furthermore, the upper unit of the mill is arranged on a track that can be rotated by a large arm that extends from the upper roof line to the ground. The Old Chatham Mill has been restored and continues to be fully functional. Chase Park now alternates between being a lively center of summer festivals and a quiet retreat.

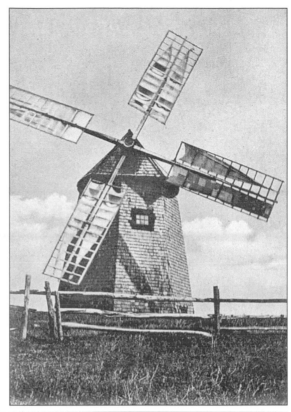

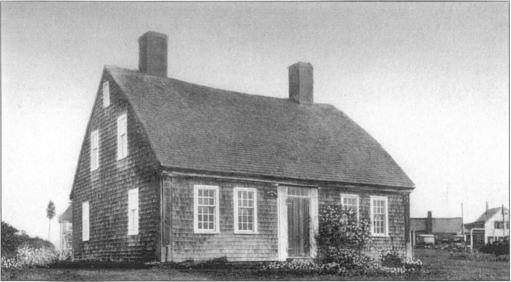

The Bow-roofed House was built for ship captain Solomon Howes in about 1800, and is an excellent example of a slightly curved roof characteristic of some early Chatham homes. The theory goes that if the curved keel of a boat successfully keeps out water, a similar shape for a roof should be equally effective for a house. The Bow-roofed House is located on Old Queen Anne Road, across from the Queen Anne Inn. One of the several bowed-roof buildings in town, the Bow-roofed House is now a guesthouse.

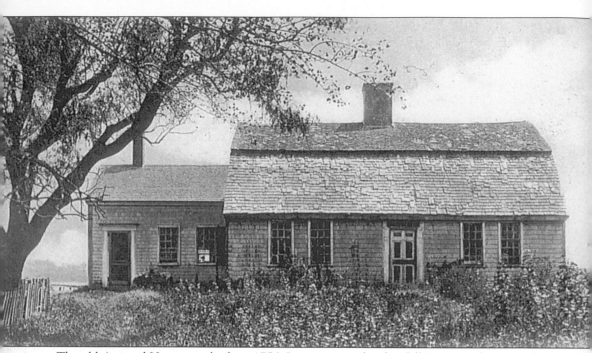

The old Atwood House was built in 1756. It is an example of a "full Cape" with a central front door and pair of windows to each side. By early Cape standards, it was a large house with a formal parlor, kitchen/living room, "borning room," and several bedrooms. At the turn of the century, it was derelict and unoccupied and the subject of numerous early postcards. The house was purchased in 1926 as the first acquisition of the newly formed Chatham Historical Society. The old house is now the center of the Atwood House Museum. There is a sign in the basement of the museum advertising the need to raise $5,000: $2,500 for the house and land, $2,500 for repairs. All funds were raised in the summer of 1926.

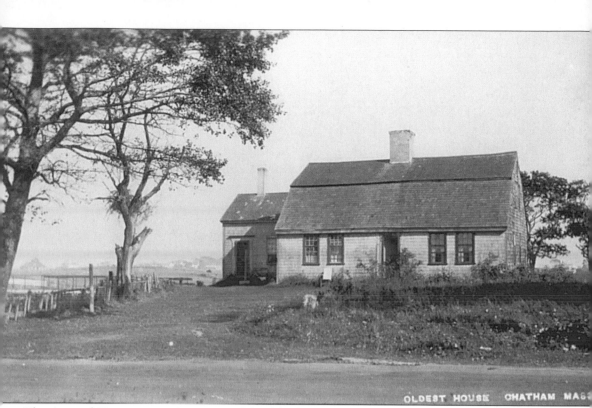

OLDEST HOUSE CHATHAM MAS§

The Atwood House is now the center of the Chatham Historical Society complex. The house was restored and offers a great example of a "full Cape" of the mid-18th century with period furniture, paintings, and household items. Expanded rooms hold the Joseph C. Lincoln collection, early Cape glass, paintings of ship captains, and a room of China trade goods. A barn containing the colorful and once controversial Stallknecht murals is attached to Atwood House. There is also an old camp moved from North Beach, an 18th century herb garden, and one of the early lenses from the Chatham Light.

One of the lasting images of Chatham for visitors in June and July is the profusion of roses that grow in some gardens along the coast. Cool nights, warm days, high humidity, fog, and sandy well-drained soils combine to make ideal conditions for growing the small-flowered Cape rambler rose. Fences, trellises, and rooflines were heavily laden with roses. The Stevens Estate in North Chatham was an often-photographed example of this riot of early summer color. Numerous postcards were made of the approach to the main house and of the front door.

This house is located where Shore Road meets Main Street near the old entrance to the Mattaquason Inn. Built as a simple farmhouse-style home, the structure has had a remarkable history of uses, including a furniture store; a tea house; and early art gallery run by Harold Dunbar, noted Chatham artist; and at various times a private home, as it is today. The original home was enlarged and glorified with Palladian windows, Victorian molding, Grecian pillars, and an elevated porch with ornate balustrade. Both the east and south entrances were surrounded by rose arbors that were the subject of postcards in the 1930s.

No visitor could spend time in Chatham without interacting with the sea. A virtual peninsula at the elbow of Cape Cod, Chatham has no point very far from water. Driving or walking about town, water—fresh or salty, warm or cold, with or without waves—is everywhere. There was a fascination in postcards with these Chatham water scenes, often with no connection to land. Many of these views must have been taken from North Beach or the beach south of the inlet into Old Harbor, where open ocean waves were always present.

Less interesting to most tourists, but equally a distinctive Cape Cod scene, were the pitch pine and oak woods that dominated those parts of Cape Cod that were not either developed with buildings or a part of active agriculture. Leaving Boston or Providence by train or car, the trees became progressively shorter as you got closer to the sea. Stunted by salt spray, periodic high winds, low soil nutrients, and occasional fires, this pine oak woods was a scruffy backdrop to the coastal and cultural parts of town.

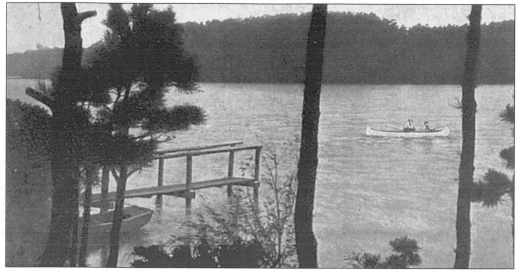

The Mayflower Tourist Camp was opened in the 1930s on White Pond about two miles west of the center of town. The facility was characteristic of a whole new way of attracting tourists to the Cape. The "camp" was a large complex of buildings including a recreation hall, cabins under the pines, a beach house, and a restaurant. The Camp took advantage of an underutilized resource in Chatham, the small freshwater ponds. Many ponds were largely unused except as a part of farms, until the 1920s when vacation homes began to be built on their shores.

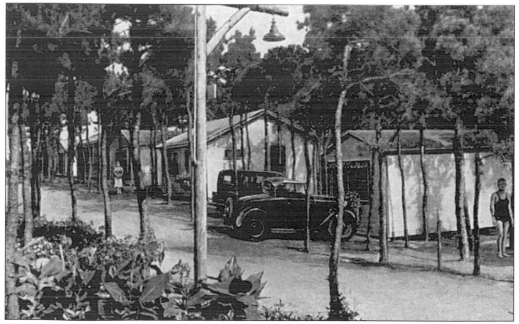

One of the characteristic features of the Cape in the 1930s and 1940s was the small cluster of cottages such as these at the Mayflower Tourist Camp. The smell of pines was a part of many tourists' summer memories of the Cape. Chatham actually had very few of these types of facilities relative to other towns on the Cape. The Mayflower Tourist Camp was converted in the 1970s to the Waterview Colony condominiums.

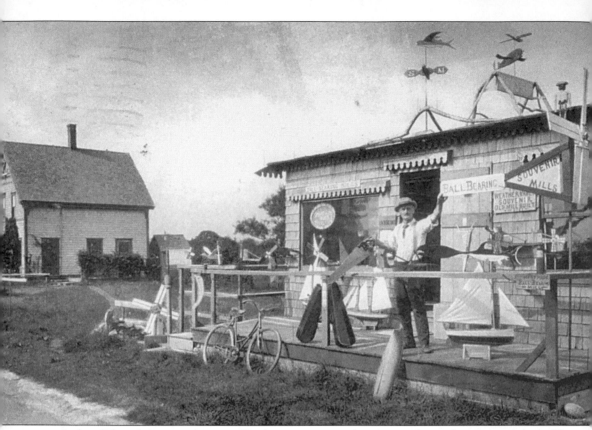

Arthur Edwards was a one-man Chatham institution bringing color and motion to town. He owned a shop on Old Harbor Road which sold Cape Cod souvenirs including wooden doorstops, lighthouses, and a series of "whirligigs" with Cape Cod themes. These small mechanical devices were powered by wind and designed originally to scare birds away from seeds newly planted in gardens. Joseph C. Lincoln's book, *Shavings*, was written using themes in Arthur Edward's life. The building where the Shaving's shop was located no longer exists. His home was barged over from Nantucket and is now "Blowin A Gale," a guesthouse. Arthur Edward's main business was renting, selling, and repairing bicycles, as well as anything with a small motor. He was typical of the imaginative Yankee characters who creatively adapted their skills to the opportunity to make money in a changing economy.

Bibliography

Adam, Antoinette. *A Cape Cod Legacy: The Story of Avis Augusta Morton Chase*. YWCA of Philadelphia: 1985.

Chatham Historical Society. *Some of Chatham Houses*. 1963–1967. (6 volumes.)

Corbett, Scott. *Cape Cod's Way*. New York: Thomas Y. Crowell Co.

Dalton, JW. *The Life Savers of Cape Cod*. Old Greenwich, CT: Chatham Press, 1902.

Eldridge, Dana. *Once Upon Cape Cod from Cockle Cove to Powder Hole*. Brewster: Stony Publishing, 1998.

Foley, Ruth Haward. *Some Chatham Neighbors of Yesterday*. Thompson and Forbes, Co., 1984.

Ives, Josephine. *A Beacon for Chatham: Eldredge Public Library, The First Hundred Years*. Eldredge Public Library, 1996.

Knapton, Ernest John. *Chatham Since the American Revolution*. The Chatham Historical Society, Inc. Orleans, MA: Thompson's Printing, 1976.

Monbleau, Marcia J. *Homesong—Chatham*. Chatham Historical Society, 1995.

Nickerson, Joshua Atkins II. *Days to Remember*. The Chatham Historical Society, Inc., 1988.

Old Village Association. *The Old Village, Chatham, Massachusetts*. Chatham, MA. Old Village Association Inc., 1997.

Ryder, Richard G. *Old Harbor Station Cape Cod*. Norwich, CT: Rain Island Press, 1990.

Smith, William C. *The History of Chatham, Mass*. 3rd ed. The Chatham Historical Society, 1981.

Snow, Edgar Rowe. *The Lighthouses of New England*. New York: Dodd, Mead and Co., 1945.

Snow, Edgar Rowe. *A Pilgrim Returns to Cape Cod*. Boston: Boston Printing Co., 1946.

Tarbell, Arthur. *Cape Cod, Ahoy! A Travel Book for the Summer Visitor*. 1932.

Tarbell, Arthur. *I Retire to Cape Cod*. New York: Stephen Daye Co., 1944.

Vuilleumier, Marion Rawson. *Churches on Cape Cod*. Taunton, Mass: William S. Sullwold Publishing.

Index